IMAGES
of America

KENNESAW

D0861647

Robert Jones

IMAGES
of America

KENNESAW

Joe Bozeman, Robert Jones,
and Sallie Loy

ARCADIA
PUBLISHING

Published by Arcadia Publishing
Charleston SC, Chicago IL, Portsmouth NH, San Francisco CA

Printed in the United States of America

Library of Congress Catalog Card Number: 2006923862

For all general information contact Arcadia Publishing at:
Telephone 843-853-2070
Fax 843-853-0044
E-mail sales@arcadiapublishing.com
For customer service and orders:
Toll-Free 1-888-313-2665

Visit us on the Internet at www.arcadiapublishing.com

*Joe Bozeman dedicates his work on this book to
the old families of Kennesaw, Georgia.
Robert Jones dedicates his work on this book to his father,
Evan S. Jones, who instilled in Robert his love of history,
and to his mother, Louise K. Jones.
Sallie Loy dedicates her work on this book to
her deceased sister, Sandra O'Dell, an educator
who died at age 37 of breast cancer.*

CONTENTS

ACKNOWLEDGMENTS

The authors of this book would like to thank the following people and organizations for their time and/or contribution of their content. Without them, this book would not have been possible.

Ann Black
Mrs. Billie Frey
Carolyn Bozeman
Carolyn Kemp
Charlotte (Hale) Smith
City of Kennesaw
Debbie Floyd
Dent Myers
Ed Hollingsworth
Eleanor Skelton Bozeman
Frank Burt Family
Fred Robertson Jr.
Gayle Croft
Helen Odum
Jack Little
Col. James Bogle
Jana Davis
Dr. Jeff Drobney
Joe Carrie
Juanita Williams
June Bozeman
Mark Smith
R. J. Patel
Rachael Shelton
Robert Ellison
Shannan Sanders
Southern Museum of Civil War and Locomotive History Archives and Library
Vivian Chandler Lee

INTRODUCTION

Kennesaw, called "Big Shanty" during the Civil War, started out in the 1830s as a railroad-worker shanty town during the construction of the Western and Atlantic Railroad. During the Civil War, Big Shanty was the site of a Georgia Militia training camp named Camp McDonald. It was also the starting point of the Andrews Raid (immortalized by Walt Disney as *The Great Locomotive Chase*). During the raid, a group of Union raiders stole a train pulled by the locomotive *General* and steamed 87 miles toward Chattanooga, tearing up track and cutting telegraph wires, before abandoning the engine just north of Ringgold, Georgia.

William Tecumseh Sherman used Big Shanty as a headquarters, supply depot, and hospital in June 1864, prior to the Battle of Kennesaw Mountain. Sherman held Big Shanty until November 1864, when he ordered Big Shanty burned to the ground. The only structure left standing after the war was a blacksmith shop. A *Boston Daily Evening Traveler* correspondent commented after the war that in the corridor from Ringgold to Atlanta, all that was left was "Ruin! ruin! ruin!"

Kennesaw incorporated in 1887. In the ensuing years, Kennesaw was in many ways a typical small town in the northern part of Georgia—built along the railroad tracks, cotton as the first engine of economic growth, stagnation during the 1920s–1950s, and then blossoming in the latter part of the 20th century as a suburb of Atlanta. But in other ways, Kennesaw would prove unique in the second half of the 20th century. In 1962, the *General* retraced its *Great Locomotive Chase* route by running under its own steam from Atlanta to Chattanooga. Kennesaw went all out for the occasion, building false fronts on downtown buildings to give the town a more 19th-century look and having many citizens dressing in Civil War–era costumes. When the *General* pulled into Kennesaw, there were 10,000 people in the downtown area to great the famous locomotive.

In the late 1960s and early 1970s, Kennesaw was back in the news as a court battle raged between the City of Chattanooga on one side and the Louisville and Nashville Railroad (L&N) and the State of Georgia on the other over ownership of the *General*. In 1970, the courts ruled that the *General* belonged to the L&N Railroad, and the L&N presented the *General* to the State of Georgia. In 1972, the *General* came home to Kennesaw to go on permanent display in the local museum.

In 1982, Kennesaw rocked the world when it passed its gun law ordinance requiring all households to own an operating firearm and ammunition. While no one has ever been charged under the law, Kennesaw has one of the lowest crime rates for a city of its size in the United States.

By the late 1980s, Kennesaw was starting to boom, as it transformed from being a sleepy rural town into being a bustling bedroom community in the Atlanta metropolitan area. Further transforming Kennesaw was the construction of the nearby Town Center Mall in the mid-1980s and the continuing growth of Kennesaw State University, which as of 2006 has 18,000 students.

In 2003, Kennesaw opened the Southern Museum of Civil War and Locomotive History, a $6-million, 40,000-square-foot museum housing exhibits on the Civil War, the Glover Machine Works collection, and, of course, the *General*.

With the assistance of many lifelong residents of Kennesaw, as well as the Southern Museum of Civil War and Locomotive History, The authors have created a collection of old photographs of Kennesaw. They include Joe Bozeman, a lifelong Kennesaw resident and local business owner; Robert Jones, president of the Kennesaw Historical Society; and Sallie Loy, senior archivist for the Southern Museum of Civil War and Locomotive History Archives and Library.

One

BUSINESSES AND RAILROADS

The first business activity in Kennesaw was that of the Western and Atlantic Railroad (W&A). The W&A, built north from Atlanta to Chattanooga, reached Kennesaw in 1838. A railroad shantytown soon appeared, and the site was eventually referred to as Big Shanty. Whether it was the W&A, Nashville, Chattanooga, and St. Louis (NC&StL), L&N, Seaboard, or CSX, railroads have been an important presence in the life of the city. Today the CSX line from Atlanta to Chattanooga is one of busiest single-track mainlines in America.

By the time of the Civil War, Big Shanty had several small stores, a small depot, a post office, a gin mill, a blacksmith shop, and a doctor's office. After November 1864, only the blacksmith shop remained. Everything else was burned to the ground by Sherman before his march to the sea.

After the Civil War, Kennesaw started to rebuild. By 1880, Kennesaw had several small stores, a gristmill, and a cotton gin operated by steam. In the early 20th century, Kennesaw enjoyed a small business boom as its importance as a shipping center and income from cotton brought some wealth to the town. During that period, several of the downtown buildings still standing today were built, including the three-story brick dry goods store, the Kennesaw State Bank, and the NC&StL depot.

In 1911, the speed limit within the city of Kennesaw was eight miles per hour. The curve below the Baptist church was known as "Dead Man's Curve," because there were so many accidents there. In the 1920s, the Dixie Highway ran through downtown Kennesaw, resulting in several service stations being built.

The good times of the early part of the century would be wiped out by the boll weevil in the 1920s and the Depression in the 1930s. After Highway 41 bypassed the city center in the 1950s, the downtown area began a long, slow deterioration. Kennesaw wouldn't recover until the 1980s, when Kennesaw became a bedroom community of Atlanta.

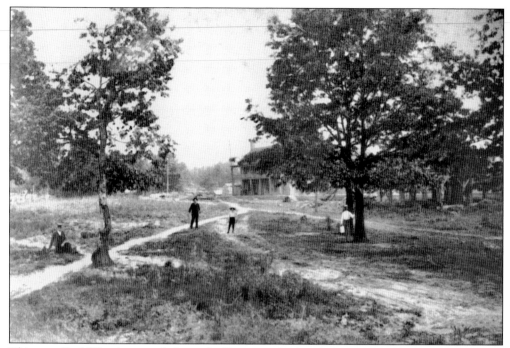

This post-Civil War photograph shows the Kennesaw Railroad House, a hotel/rest stop built by the W&A to replace the Lacy Hotel (burned to the ground by William Tecumseh Sherman in 1864). The man with the cane is Judge G. T. Carrie, the manager. (From the collection of Gayle Croft.)

This early-20th-century photograph shows Nellie (on the porch in the background) and Helen Garrett (foreground) posing in front of a railroad "shanty" or section house. Nellie and Helen were daughters of Henry C. Garrett, an NC&StL Railroad section foreman. According to Garrett's obituary, he had "only one reportable injury among his men during the fourteen (14) years he served as Foreman, which is a most excellent record." (From the collection of Helen Odum.)

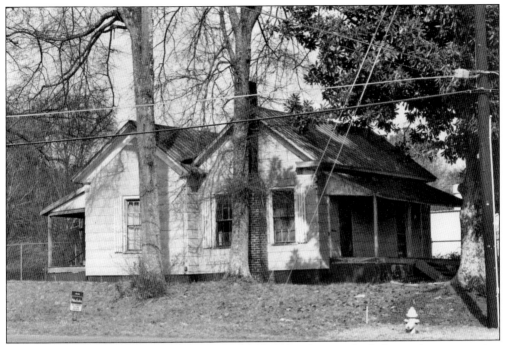

The first structures built in Kennesaw were railroad worker shanties, built during the construction of the Western and Atlantic Railroad in the 1830s and 1840s. The shanties pictured here probably date from the late 19th century. They were destroyed in 1994—the last of the Kennesaw railroad shanties. (Photograph by Robert Jones.)

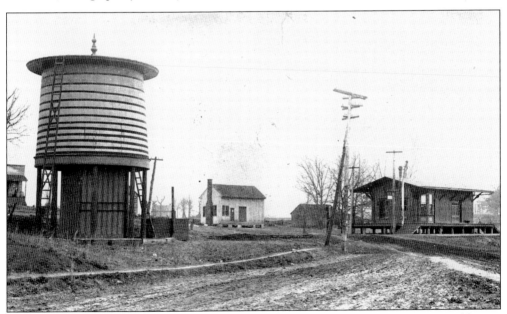

This rare 1908 photograph of the depot area in Kennesaw shows (from left to right) an old store, the NC&StL water tower, the old depot (white building), and the "new" depot. Note that the white stone marker for the *General* has yet to appear, and the railroad crossing is much less elevated than it is in 2006. (From the collection of Joe Bozeman.)

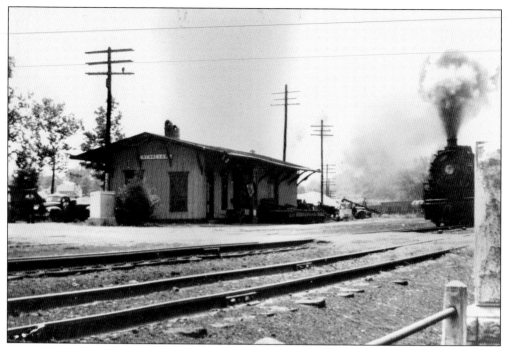

A NC&StL steam engine chugs past the Kennesaw Depot, *c.* 1930. (From the collection of Col. James Bogle.)

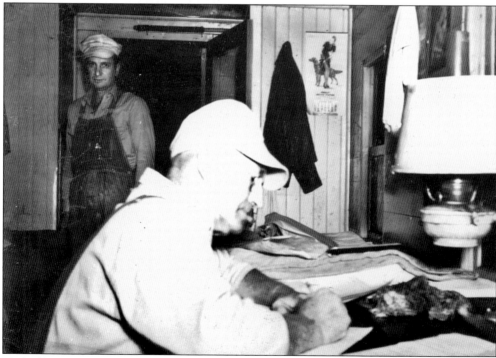

Nashville, Chattanooga, and St. Louis Railroad conductor E. M. "Lige" Skelton works on paperwork in his caboose. The man in the background is flagman L. R. King. (From the collection of Eleanor Skelton Bozeman.)

NC&StL conductor George Skelton poses in 1948. This caboose, NC&StL No. 41, is restored and in running condition at the Tennessee Valley Railroad Museum in Chattanooga. (From the collection of Joe Bozeman and Billie Frey.)

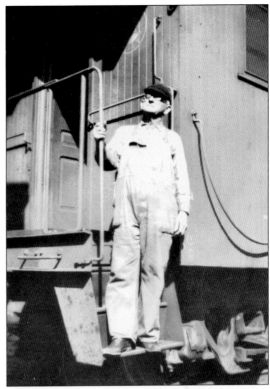

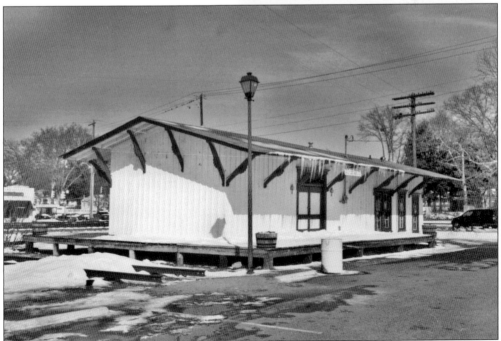

The c. 1908 NC&StL railroad depot handled both freight and passenger service for many years. At various times, it has had "Kennesaw" or "Big Shanty" painted on the side. This view was taken during February 1993. (Photograph by Robert Jones.)

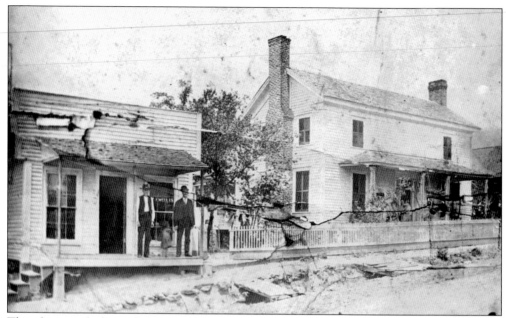

This photograph shows the office (left) of renowned Kennesaw doctor John William Ellis, born in Forsyth County on June 11, 1868. Dr. Ellis served as a physician in Kennesaw for over 50 years, starting in 1900. For the first half of those 50 years, Dr. Ellis traveled via horse and buggy to visit his patients. The building on the right may have been his home. (From the collection of Carolyn Kemp.)

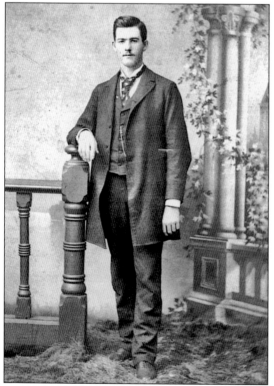

This studio portrait of the young Dr. John William Ellis was taken in Atlanta. Ellis began his practice on April 4, 1900, after attending classes at Emory (then called Southern Medical College) and the Georgia College of Eclectic Medicine and Surgery. (From the collection of Carolyn Kemp.)

This photograph shows Dr. John William Ellis as a middle-aged man. In addition to his duties as a doctor, he also worked as a farmer and ran a small drugstore. He died in 1950. (From the collection of Carolyn Kemp.)

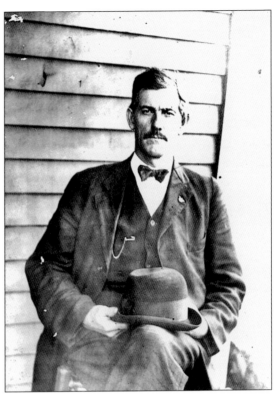

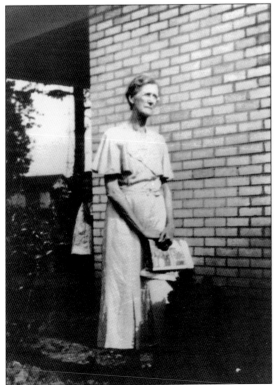

Carrie Boring, the wife of Dr. Ellis, was born in Woodstock, Georgia. She died in July 1944. (From the collection of Carolyn Kemp.)

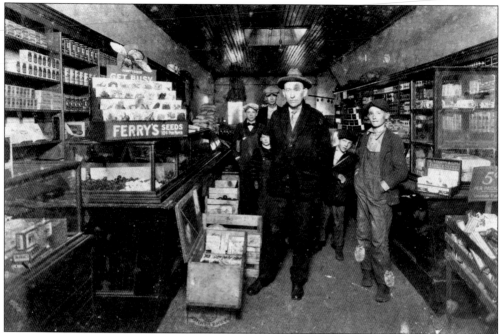

This interior photograph shows the dry goods store located in the bottom of a three-story brick building in downtown Kennesaw, c. 1910. Pictured is L. Scroggs. James Lewis built the structure c. 1902. James Lewis would serve three different stints as mayor of Kennesaw. (From the collection of Rachael Shelton.)

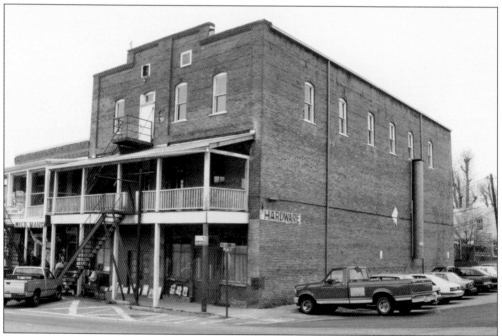

This 1996 photograph of the three-story brick building in downtown Kennesaw shows its last use as a hardware store before abandonment. The third floor of the building once served as a Masonic hall. (Photograph by Robert Jones.)

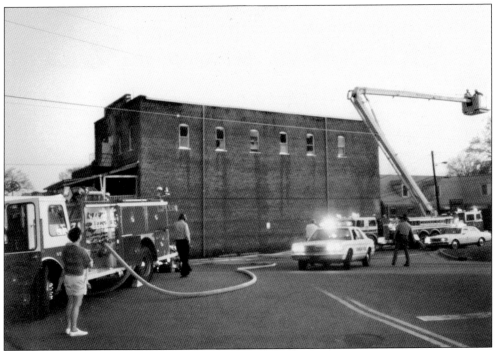

A fire broke out in downtown Kennesaw in the 1970s. The three-story brick building was badly damaged. (From the collection of Eleanor Skelton Bozeman.)

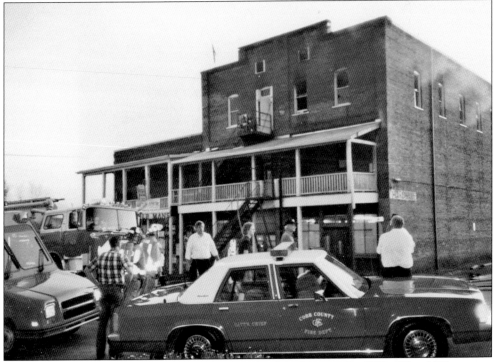

This frontal view shows the fire at the three-story brick building in the 1970s. The old Kennesaw State Bank building can be seen on the left. (From the collection of the Frank Burt family.)

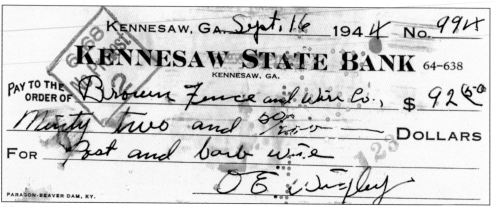

This 1944 check was drawn on the Kennesaw State Bank. The Kennesaw State Bank was chartered around 1910 and capitalized for $25,000. It closed its doors forever in 1952. (From the collection of Dent Myers.)

This photograph from the 1920s is of the Carrie Livery stable, which was located behind the modern-day car lot on Main Street. There was a blacksmith shop nearby. The name of the horse was Old Frank. (From the collection of Joe Carrie.)

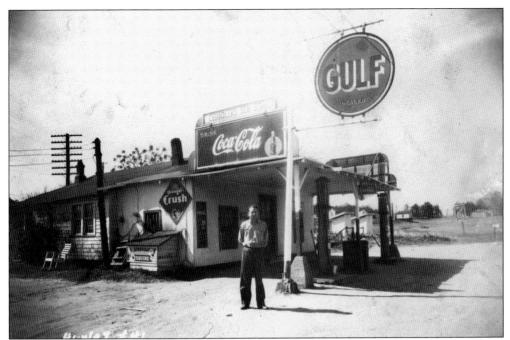

This 1947 photograph shows Chandler's Service Station, which used to stand on South Main Street. Pictured is W. D. "Bill" Chandler. Note the signs for Coca-Cola and Orange Crush. (From the collection of Vivian Chandler Lee.)

Mary Baker and Herbie Vann pose in front of Bozeman Grocery (now the Whistle Stop Café) on Main Street in Kennesaw, c. 1952. (From the collection of Eleanor Skelton Bozeman.)

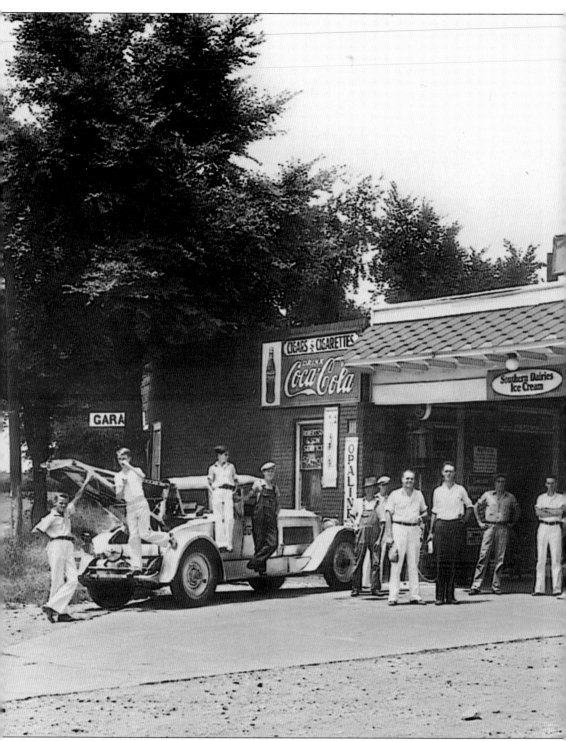

A *c.* 1935 photograph shows Robertson and Son Garage (originally the Robertson—McGhee Garage) in downtown Kennesaw. The garage was located near the "Dead Man's Curve" north of the three-story brick store. Fred Robertson Sr. is third from the right in the photograph; his

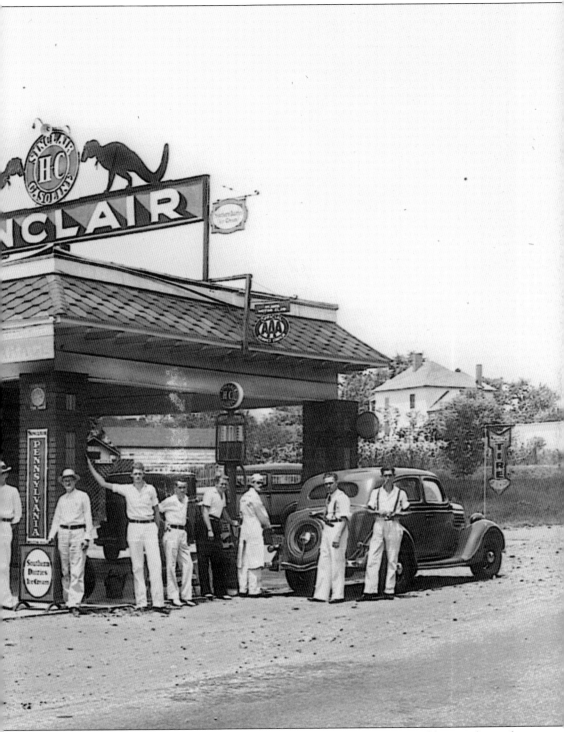

father, E. S. Robertson, is sixth from the right. Note the wonderful Sinclair emblem on the roof, the two Southern Dairies Ice Cream signs, the Coca-Cola sign, and the AAA sign. (From the collection of R. J. Patel.)

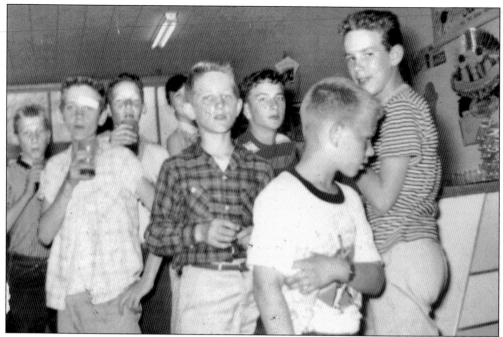

These two pictures were made at the Kennesaw Drug Store in May 1958 by Paul and Thelma Black, the owners. It was a wonderful place for kids to gather after school and enjoy a cherry Coke. The building that the drug store occupied is now Eaton Chiropractic. In this photograph are pictured, from left to right, Tommy Atkins, Jack Weeks, Allen Black, Jerry Weeks, Butch Thompson, unidentified, and Joe Bozeman. (From the collection of Joe Bozeman.)

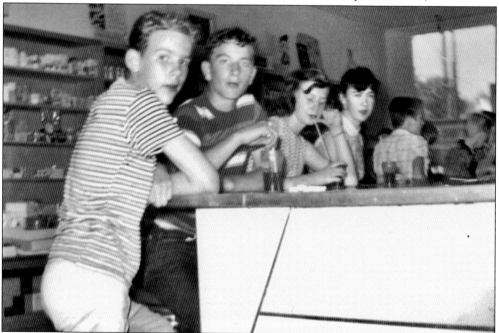

Pictured in this photograph, from left to right, Joe Bozeman, Butch Thompson, Jane Bailey, and Bobbie Fultz enjoy their soft drinks at the Kennesaw Drug Store. (From the collection of Joe Bozeman.)

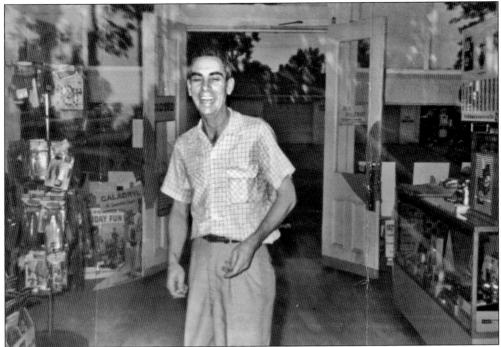

Paul Black served as the proprietor of the Kennesaw Drug Store in the late 1950s and early 1960s. He is pictured inside the store in 1958. (From the collection of Ann Black.)

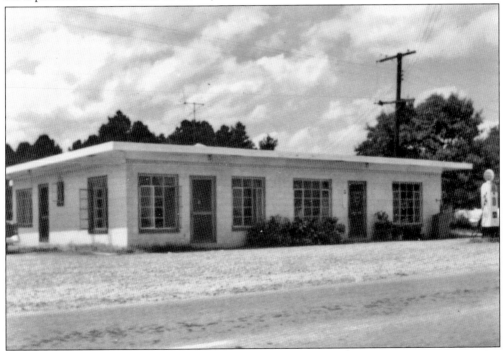

This 1950s photograph shows the Chandler Barber Shop (left), operated by W. D. "Bill" Chandler, and Chandler Grocery Store, operated by Ruby Ellison Chandler. The store was located near McCollum Airport. (From the collection of Vivian Chandler Lee.)

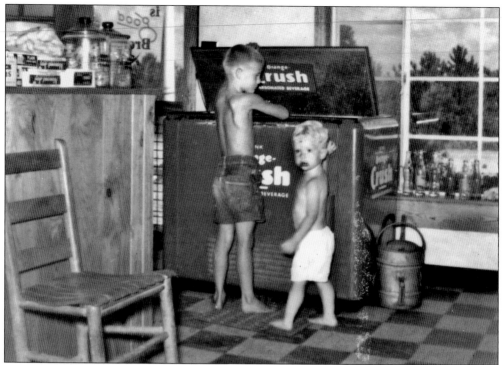

These young boys are helping themselves to a soft drink inside the Chandler Grocery Store in the early 1950s. (From the collection of Vivian Chandler Lee.)

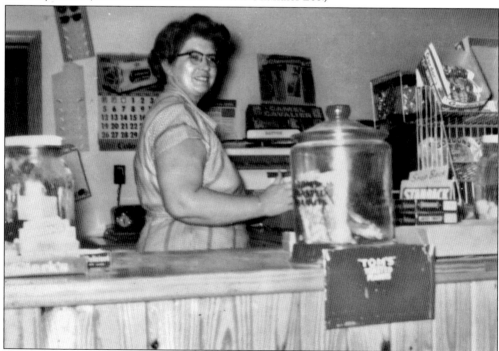

Ruby Chandler managed the Chandler Grocery Store and is seen here manning the counter in the early 1950s. (From the collection of Vivian Chandler Lee.)

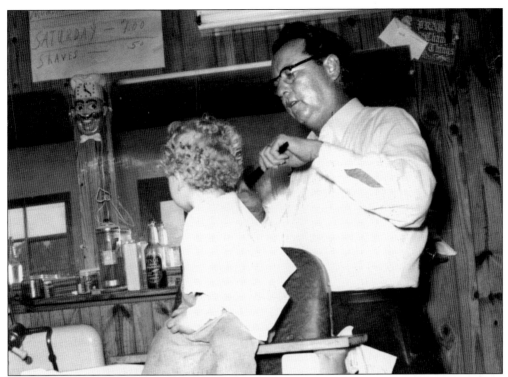

Bill Chandler cuts the hair of his grandson, Doug Lee, in the aforementioned Chandler Barber Shop in 1956. (From the collection of Vivian Chandler Lee.)

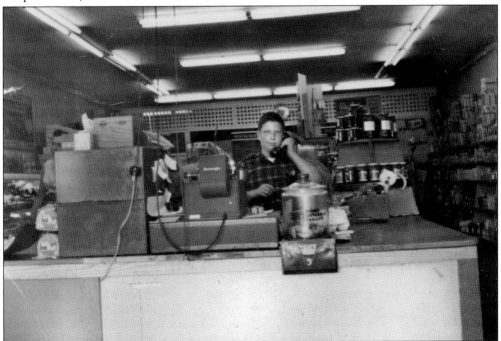

Bobby Bozeman takes a telephone order in Bozeman's Grocery Store in the 1950s. This is now the Whistle Stop Café. (From the collection of Eleanor Skelton Bozeman.)

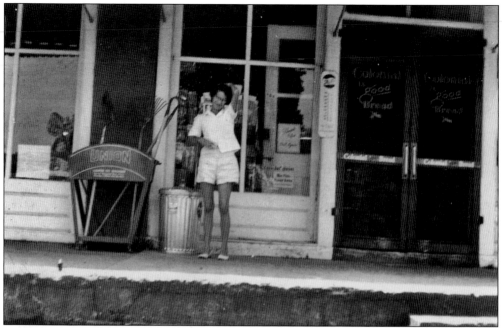

A *c.* 1960 photograph shows Wooten's Grocery on Main Street. The sign on the door says, "Colonial is good bread." (From the collection of Ann Black.)

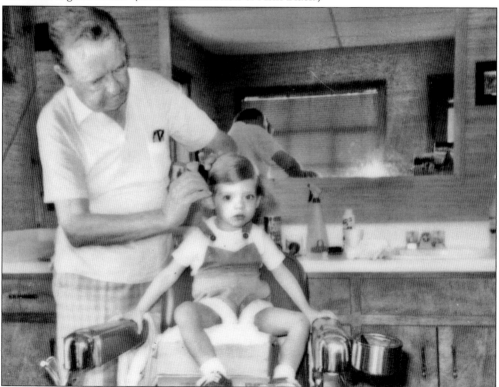

David Lee receives his first haircut from Granddad Chandler. (From the collection of Vivian Chandler Lee.)

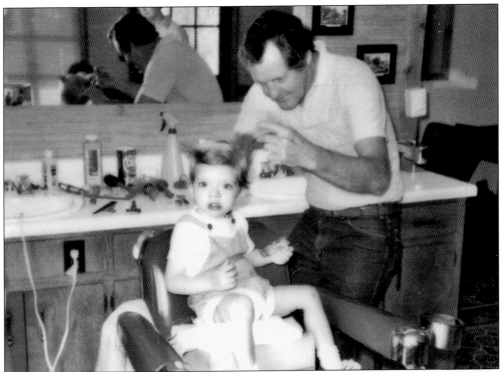

Hugh Smith completes the haircut of David Lee. (From the collection of Vivian Chandler Lee.)

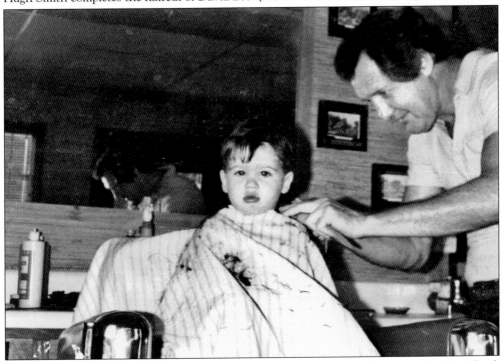

Hugh Smith performs his art at the Smith Barber Shop. (From the collection of Debbie Floyd, who now owns Floyd's Barber Shop in Kennesaw.)

This photograph shows how the Chandler Grocery Store and Barber Shop looked in 1999. This site has since been demolished to make way for a landscaping store. (From the collection of Vivian Chandler Lee.)

Two

CHURCHES

As in most small Southern towns, religion has always played an important part in Kennesaw culture. The Kennesaw First Baptist Church and the Kennesaw Methodist Church were built in 1877, providing a stabilizing influence on a community still struggling to recover after the ravages of Sherman's Atlanta Campaign of 1864. Since then, many other churches and denominations have come to Kennesaw, including St. Catherine of Sienna Catholic Church.

Kennesaw First Baptist Church was organized in August 1877 and had its first meeting in the upstairs portion of the old Ben Hill Store. Charter members included Mrs. H. A. Butler, Lucinda Butler Adams, Bess Whitfield, and Mrs. Baldwin Cox. The first church building was built two years later, in June 1879, on Cherokee Street. A new church building was dedicated in November 1902 on the North Main Street site that the Kennesaw First Baptist Church occupies today.

The Kennesaw Methodist Church began as Kennesaw Methodist Episcopal Church in February 1877. Like the Kennesaw First Baptist Church, early services were held in the upstairs of a Kennesaw store. Charter families include the names Brinkley, Carrie, Chalker, Grambling, and McRae. Beginning in 1881, the church occupied a site on Cherokee Street up the hill from the modern Southern Museum of Civil War and Locomotive History. In 1981, the church moved to its present location on Ben Hill Road.

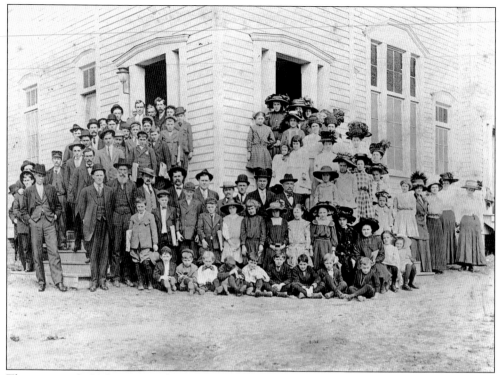

This is an early-20th-century photograph of the congregation of Kennesaw Methodist Church. (From the collection of Jack Little.)

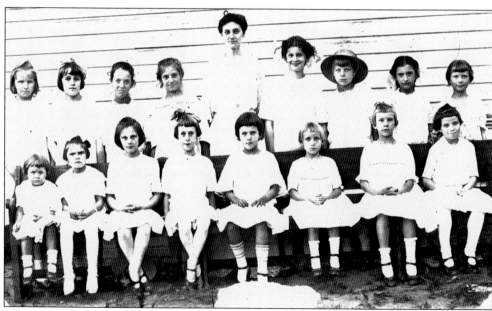

This c. 1915 photograph shows a Sunday school class at Kennesaw First Methodist Church. (From the collection of Charlotte [Hale] Smith.)

This photograph was taken on the front steps of Kennesaw Methodist Church, now a wedding chapel, on September 25, 1927. The house in the background still stands and is used as the office for the wedding chapel today. Pictured from left to right are Mildred Lewis, Sam Dameron, Joe Bozeman Sr., and Carolyn Skelton. (From the collection of Billie Frey.)

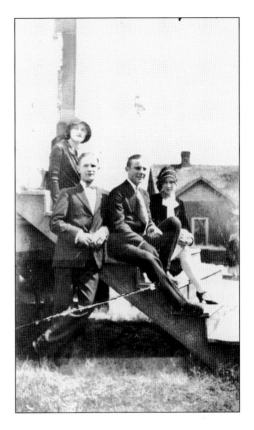

This early-1950s photograph shows a Kennesaw Methodist Sunday school class. (From the collection of Mrs. Billie Frey.)

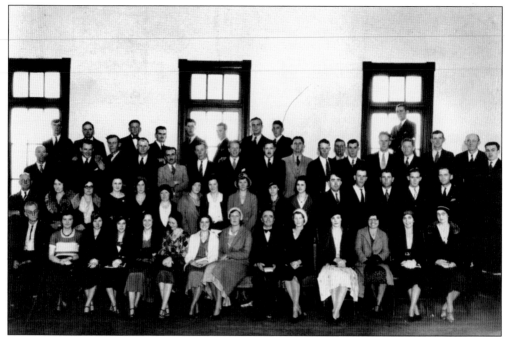

This congregational photograph was shot in the interior of the old Kennesaw Methodist Church. (From the collection of Fred Robertson Jr.)

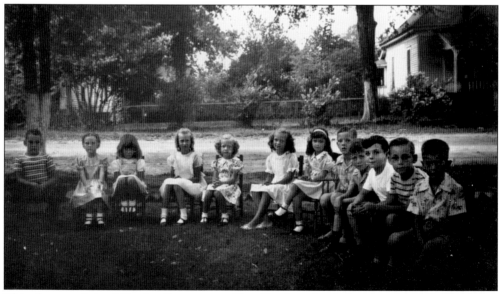

This photograph is of Carolyn Bozeman and her Sunday school classmates in 1951. The house on the right was torn down to make way for the Kennesaw branch of the Cobb County Library. (From the collection of Mrs. Billie Frey.)

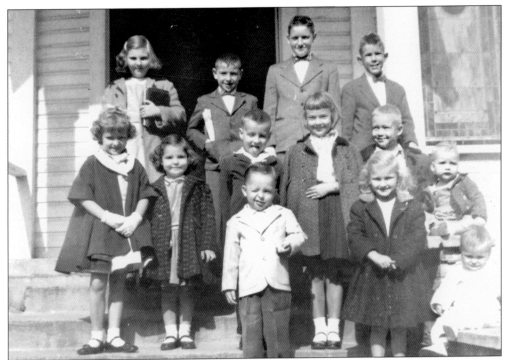

Young children pose for their Kennesaw Methodist Sunday school class photograph c. 1950. (From the collection of Mrs. Billie Frey.)

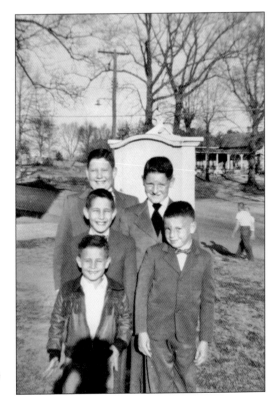

This photograph was shot from the front of Kennesaw Methodist Church in 1956 looking toward the Sims House. Pictured are (left, top to bottom) Bobby Bozeman, Mickey Bozeman, and Randy Bozeman; (right, top to bottom) Allen Black and Jerry Black. (From the collection of Ann Black.)

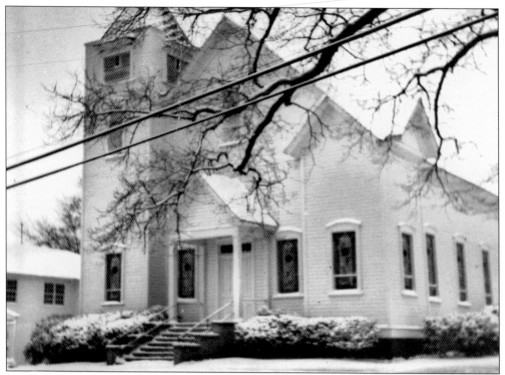

This photograph of the original Kennesaw Methodist Church on Cherokee Street was taken in 1965. The church moved to a new facility in 1981. (From the collection of Joe Bozeman and Mrs. Billie Frey.)

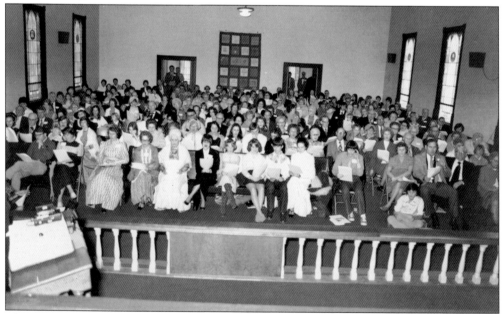

This photograph shows the congregation of Kennesaw Methodist Church celebrating their centennial. The church began as Kennesaw Methodist Episcopal Church in February 1877. (From the collection of Mrs. Billie Frey.)

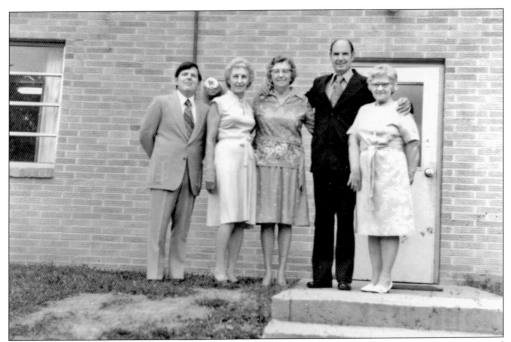

The Centennial Committee of the Kennesaw First Baptist Church poses in 1977. Those pictured are, from left to right, Rev. J. Tod Zieger, Helen Odum, Kate Hildenbrand, Buddy Leonard, and Helyn Watts. (From the collection of Helen Odum.)

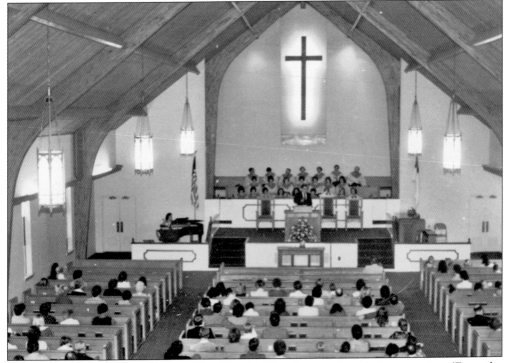

This interior view of the Kennesaw First Baptist Church was taken during a service. (From the collection of Helen Odum.)

Folks gather for a service at the Kennesaw First Baptist Church in the mid-1970s. (From the collection of Helen Odum.)

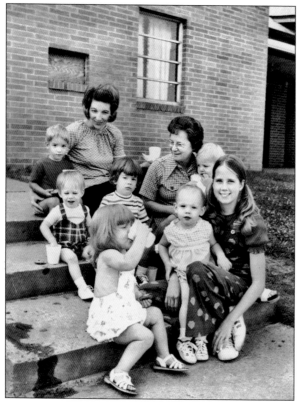

This June 1975 photograph shows children enjoying a drink at vacation Bible school at the Kennesaw First Baptist Church. (From the collection of Helen Odum.)

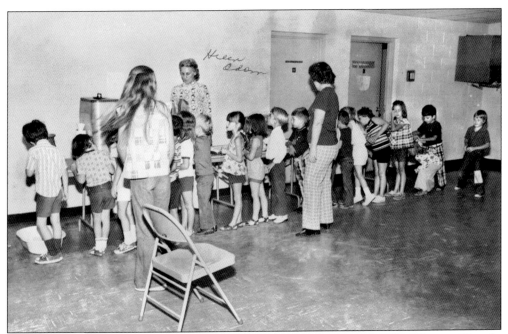

Refreshments are being served at vacation Bible school at the Kennesaw First Baptist Church. The photograph is from June 1975. (From the collection of Helen Odum.)

This mid-1970s photograph shows people heading to services at the Kennesaw First Baptist Church. The person in the flowered shirt on the far right is future mayor J. O. Stephenson. The house in the background was one of the three Hill family houses in Kennesaw. (Photograph by Gaines Studio; from the collection of Helen Odum.)

This mid-1970s photograph shows the preacher coming out of Kennesaw First Baptist Church. (From the collection of Helen Odum.)

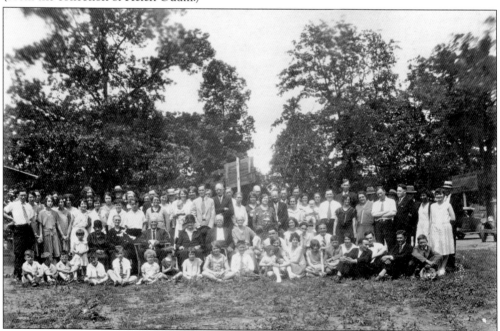

A Shiloh Methodist Church homecoming is pictured in the 1920s. Another source says that this is a photograph from a family reunion at Hickory Grove Baptist Church. (From the collection of Mrs. Billie Frey.)

Three

THE GENERAL

One of the most famous events of the Civil War began in Kennesaw (Big Shanty) on April 12, 1862, when 20 Union spies, led by civilian James J. Andrews, seized a Confederate locomotive named the *General.* The train was stopped for a 20-minute breakfast break at the Lacy Hotel. The Lacy Hotel was burned to the ground in November 1864 by Gen. William Tecumseh Sherman.

The objective of the raid was to steam the train to Chattanooga, burning bridges, tearing up track, and cutting telegraph wires along the way. The raid entered into legend because the conductor of the train, William A. Fuller, and Western and Atlantic Railroad superintendent of motive power Anthony Murphy pursued the stolen train for 87 miles by foot, handcar, and three different locomotives, until the train was finally abandoned two miles north of Ringgold, Georgia.

The Great Locomotive Chase has been commemorated in numerous books and at least two major Hollywood movies, including the 1926 *The General,* starring Buster Keaton, and the 1956 Walt Disney movie *The Great Locomotive Chase,* starring Fess Parker.

On April 14, 1962, the reconditioned (by the Louisville and Nashville Railroad) *General* ran under its own steam from Tilford Yard in Atlanta to Chattanooga. The run was in commemoration of the 100th anniversary of the Andrews Raid on April 12, 1862.

Kennesaw went all out for the occasion—the city went so far as to erect false storefronts on the west side of Main Street to give the town a fuller and more "old time" feeling. Period dress was common among the 10,000 people who were on hand when the *General* steamed by the old Kennesaw Depot.

In 1967, the L&N Railroad gave the *General* to the State of Georgia. After a three-year court battle between Chattanooga, Tennessee, and the L&N Railroad, the *General* was presented to the State of Georgia by the railroad in 1972. In February 1972, the train was moved to Kennesaw on a railroad flatcar, transferred to the back of a truck, and eventually eased into the back of the current Kennesaw Civil War Museum.

On April 12, 1972, the Big Shanty Museum (now the Kennesaw Civil War Museum) opened to the public in the old Frey cotton gin. The *General* had come home to Kennesaw.

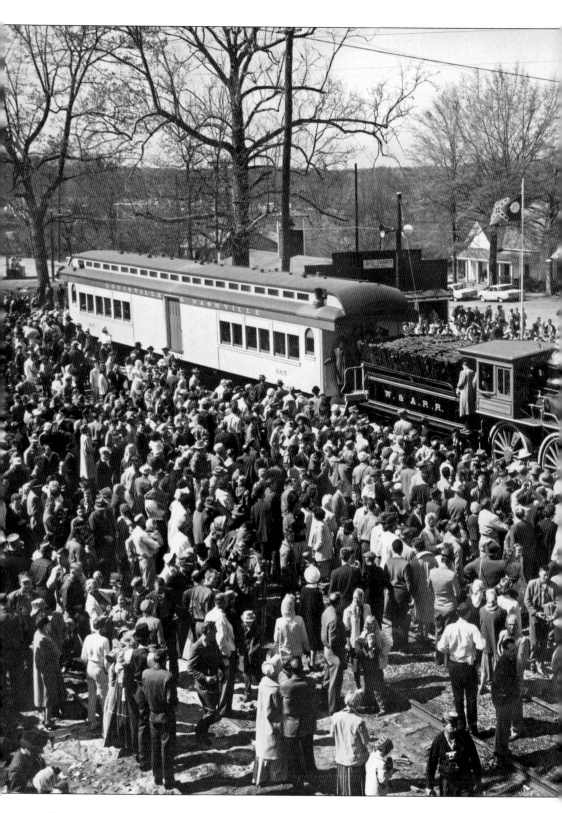

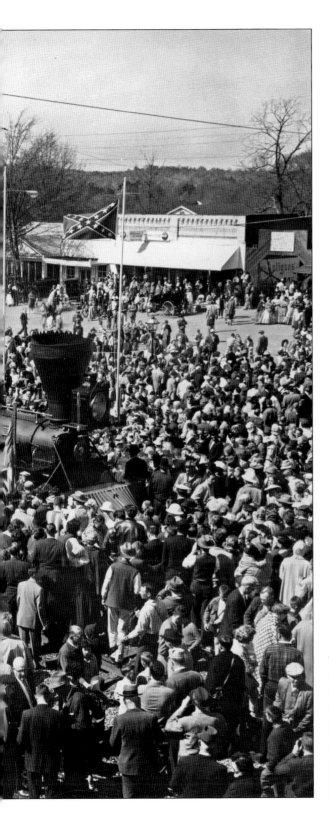

This wonderful photograph of the 1962 centennial run of the *General* shows part of the crowd of 10,000 mobbing the *General* as it pulls up to the depot in Kennesaw. The photograph was taken by C. Norman Beasley, of the L&N Railroad. (Courtesy Southern Museum of Civil War and Locomotive History.)

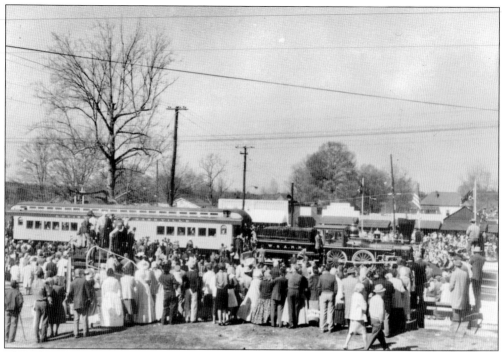

This photograph of the 1962 centennial run shows some of the false fronts erected for the event on Main Street. (From the collection of the Frank Burt family.)

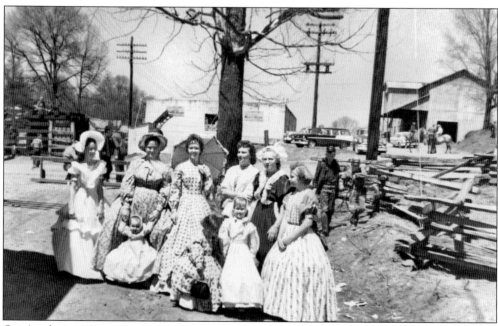

On April 14, 1962, many Kennesaw residents turned out in period dress to great the *General*. Pictured are, from left to right, Elaine Freeman, Fannie Freeman, Mitzie Freeman, Elizabeth (Betty) Freeman Ellison, Christana Gay Ellison, June Freeman Franklin, Lydia Franklin, Lillie B. Freeman, and Phyliss Franklin. (From the collection of Robert Ellison.)

At the 1962 centennial run of the *General*, those pictured are, from left to right, Fannie Freeman, Betty and Chris Ellison, Robert Ellison, June Franklin, and Lydia Freeman. (From the collection of Robert Ellison.)

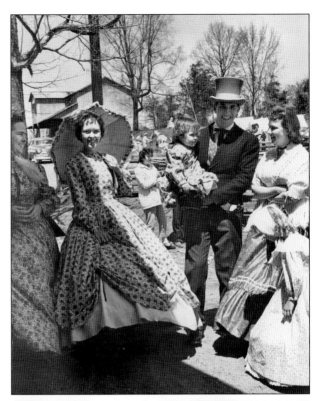

Civil War reenactors were out in full force in Kennesaw at the 1962 centennial run of the *General*. (From the collection of Vivian Chandler Lee.)

From the 1962 centennial run of the *General*, this is Patty Bell, daughter of Norman Bell. The photograph was taken beside the faux blacksmith shop erected for the event. (From the collection of Mark Smith.)

This photograph shows more Confederate reenactors participating at the 1962 centennial in the field next to the depot. (From the collection of Ann Black.)

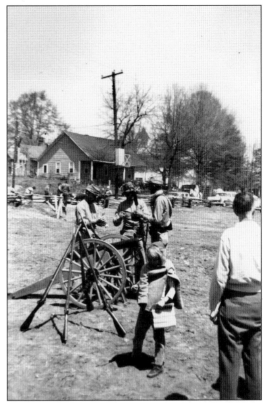

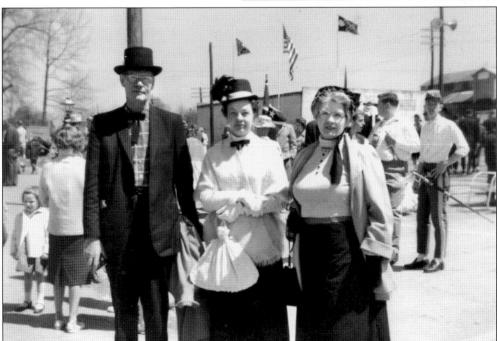

Pictured at the 1962 centennial run of the *General* are, from left to right, Diz Dismukes, Ruby Chandler, and Inez Dismukes. (From the collection of Vivian Chandler Lee.)

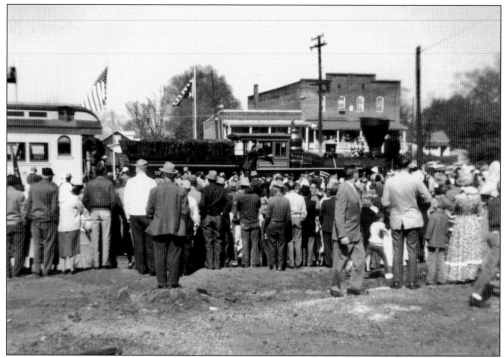

The crowd surrounds the *General* in 1962 in downtown Kennesaw. Note the three-story brick building in the background. (From the collection of Vivian Chandler Lee.)

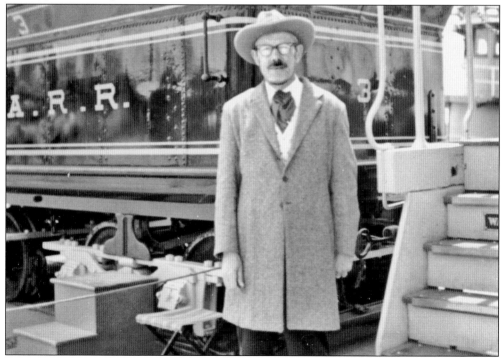

Lifetime Kennesaw resident C. L. "Hoss" Bozeman served as flagman on the historic 1962 run of the *General*. (From the collection of Joe Bozeman.)

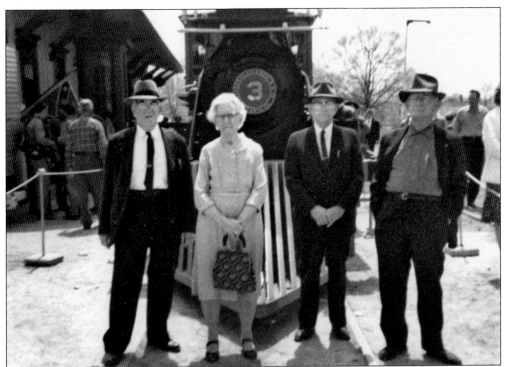

In 1963, the *General* made one more run under its own steam, retracing the route of the Andrews raid. Note the Kennesaw depot to the left. Pictured from left to right are E. M. Skelton, retired NC&StL conductor; Lela Arrington, widow of NC&StL baggage master Sid Arrington; Ed Skelton, retired NC&StL conductor; and George Skelton, retired NC&StL conductor. (From the collection of Carolyn Bozeman.)

Between 1967 and 1970, a court battle raged between Chattanooga and the L&N Railroad and the State of Georgia over ownership of the *General*. This photograph shows Bob Bozeman with a group of Kennesaw children giving the V for Victory sign after a court awarded ownership of the *General* to the L&N. (From the collection of Dent Myers.)

From left to right, Louis Watts, Nina Frey, and Bob Bozeman were all members of the Big Shanty Historical Society in the late 1960s. Here they are shown planning for the return of the *General* to Kennesaw. (From the collection of Eleanor Skelton Bozeman.)

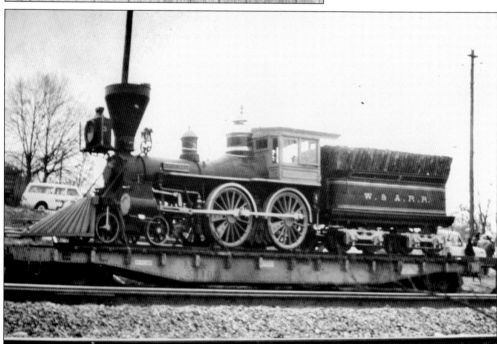

In February 1972, the *General* returned home to Kennesaw for good, shipped in by the L&N Railroad via flat car. (Courtesy of the Southern Museum of Civil War and Locomotive History Archives and Library.)

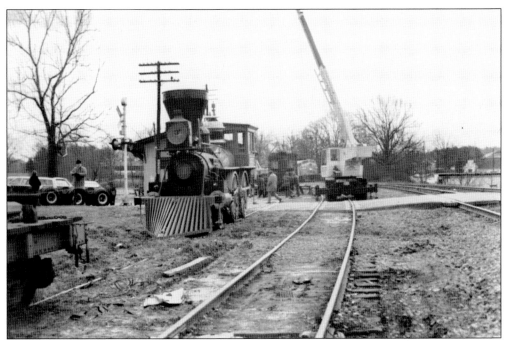

The *General* was removed from the back of the flatcar by a crane. (From the collection of Joe Bozeman.)

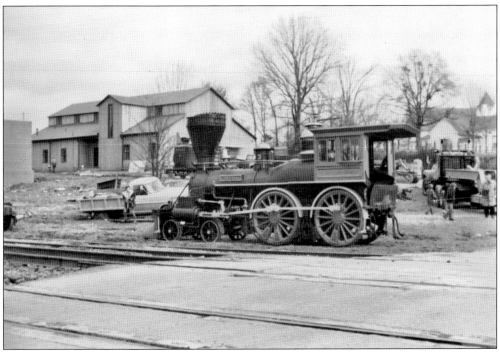

The train was placed on the track without its tender. In the background left is the Frey cotton gin, soon to be the permanent home of the *General*. (From the collection of Joe Bozeman.)

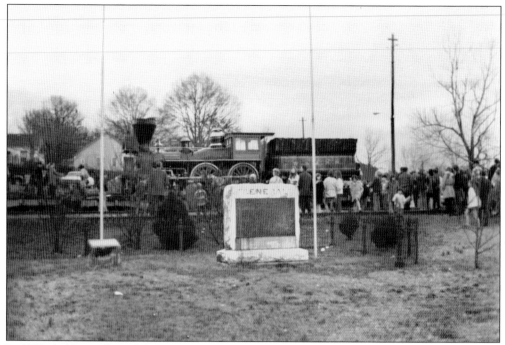

In 1972, the *General* stands behind the marker commemorating the Andrew's Raid of 1862. (From the collection of Joe Bozeman.)

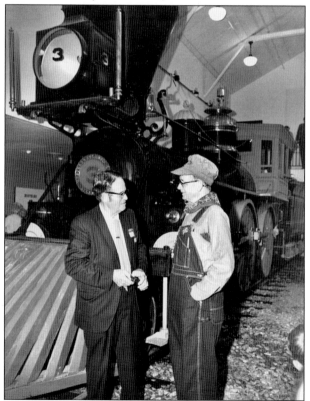

Gov. Lester Maddox (right) stands with Joseph W. Parrott (left) at the newly opened Big Shanty Museum. In 1967, Governor Maddox signed a resolution calling for the return of the *General* to Kennesaw. Joseph W. Parrott is the grandson of Jacob Parrott, winner of the first Congressional Medal of Honor (awarded for his participation in the Andrews Raid). (Courtesy of the Southern Museum of Civil War and Locomotive History Archives and Library.)

Four

GOVERNMENT

Although in existence since the late 1830s (and having a post office since 1853), Kennesaw didn't officially incorporate until 1887. The Articles of Incorporation were approved by the General Assembly of the State of Georgia on September 21, 1887, and defined the city limits as follows: "The corporate limits of said town shall extend one half mile, north, south, east, west from the depot of the Atlantic & Western Railroad."

Although the Articles of Incorporation called for the election of a mayor and four councilmen "within six months after the passage of this Act, or so soon thereafter as practicable," Kennesaw didn't get around to electing its first mayor (J. S. Reynolds) until 1891.

The most famous act of the Kennesaw city government occurred in 1982, when the Kennesaw City Council unanimously passed a law requiring all heads of households to maintain a firearm and ammunition. The law was passed partly in response to a law passed in Morton Grove, Illinois, (June 1981) banning private possession of handguns. Since passage of the law, the burglary rate in Kennesaw has gone down significantly, while the rate in Morton Grove has gone up. Today the burglary rate in Kennesaw is among the lowest of any city of its size in the United States.

The law is part of the Civil Defense and Disaster Relief section of the town code. The following people were exempt under the law: those that suffer from physical disabilities, those who conscientiously oppose use of firearms, convicted felons, and paupers.

While no one has ever been charged under the Kennesaw gun law, it remains an active law—and seems to be having a significant impact on crime.

In recent years, the Kennesaw city government has greatly expanded the city park system, opened an impressive community center, revitalized the downtown area, and supported the building of the Southern Museum of Civil War and Locomotive History.

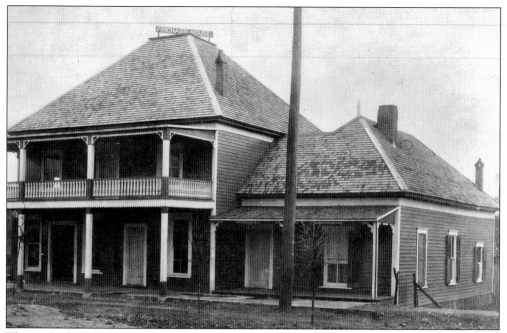

This is the boardinghouse and blacksmith shop of Mayor George W. Prichard, who served as mayor, marshal, and councilman at various times between 1898 and 1925. The structure was located on Lewis Street. It was torn down in 1948. Note the Prichard House sign on the roof. (Courtesy of the City of Kennesaw.)

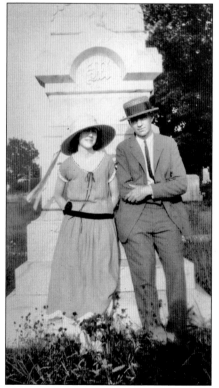

The city cemetery (now known as the Kennesaw City Cemetery) was established during the Civil War in 1863 on the farm of Thomas Summers (discussed elsewhere in this book). The first person buried in the cemetery was Lucius Summers, son of Thomas and Casander Summers. In this photograph, Flora Lester and a friend pose in the 1920s. (From the collection of Mrs. Billie Frey.)

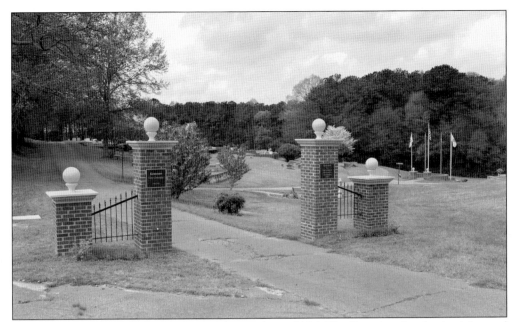

The city cemetery underwent some visual upgrades in 2004. The Summers family plot is located to the right of this photograph, in a small, fenced-in area. It is still possible to buy plots in the city cemetery. (Photograph by Robert Jones.)

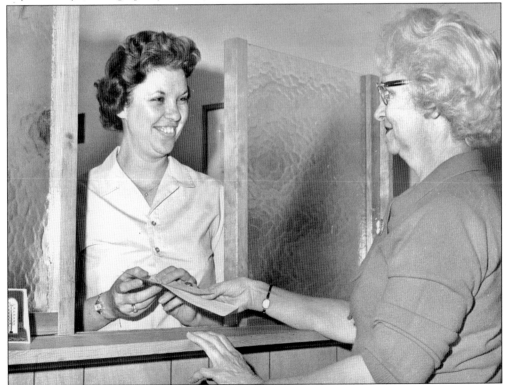

Joyce McCormack and Carolyn Bozeman chat at the Kennesaw City Hall cashier window in the 1960s. (From the collection of Mrs. Billie Frey.)

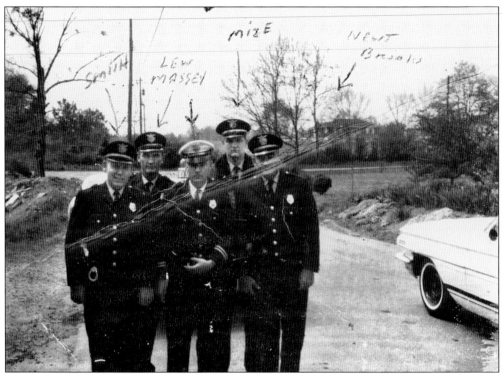

This 1968 photograph shows the Kennesaw police force, led by Ed Hollingsworth (middle). Also pictured, from left to right, are officers ? Smith, Lew Massey, ? Mize, and Newt Brooks. (From the collection of Ed Hollingsworth.)

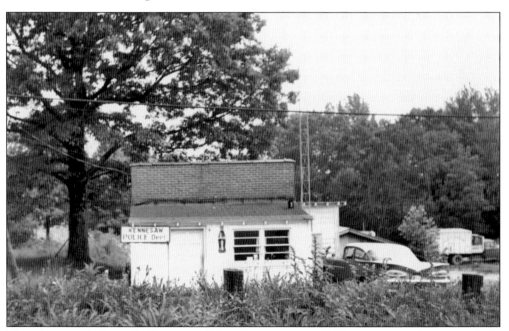

This photograph shows the Kennesaw Police Department in 1969—not a very glamorous abode for the city jail. (From the collection of Joe Bozeman.)

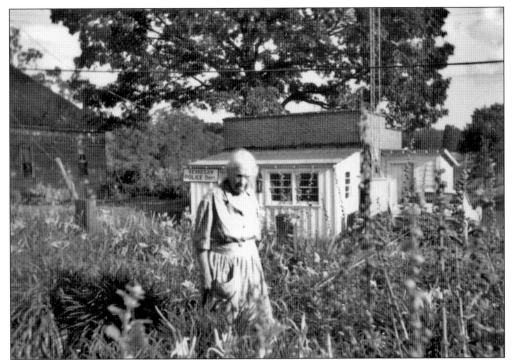

In another view of the old Kennesaw jail, here is Cora Skelton in July 1971, standing in her flowerbed near the jail. (From the collection of Joe Bozeman.)

This 1969 photograph of the old city hall, once located on the corner of Cherokee and Main Streets, is a far cry from the Kennesaw City Hall of the 21st century. (From the collection of Ann Black.)

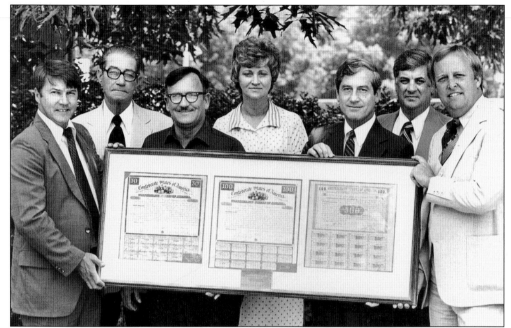

This May 1981 photograph shows the presentation to Big Shanty Museum of some Civil War bonds. Pictured are, from left to right, Darvin Purdy, mayor; Gordon Coker, councilman; J. O. Stephenson, councilman; Susan Rackley, city clerk; Ralph Baker, president of Cobb County Bank; Jerry Worthan, councilman; and Tommy Boland, vice president of First Atlanta Bank. (Courtesy of the City of Kennesaw.)

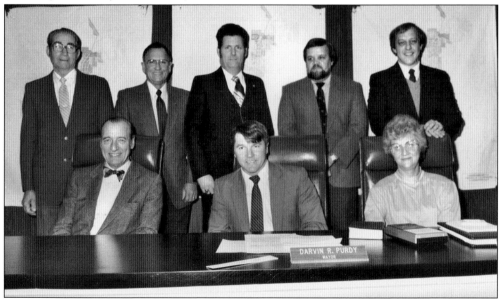

This 1985 photograph of the mayor and council shows several of the key players that passed the famous gun law in 1982, including Attorney Fred Bentley Sr. (seated left), Mayor Darvin Purdy (seated center), and Councilman J. O. Stephenson (standing, second from left). Also pictured are City Clerk Susan Rackley (seated, right) and, from left to right, Councilmen Gordon Coker, Mike Fredenburg, Ben Robertson, and Pat Ferris. (Courtesy of the City of Kennesaw.)

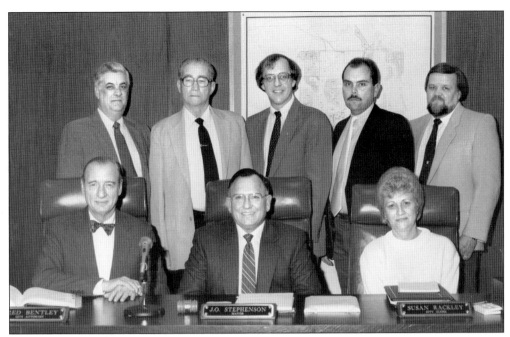

The city council and mayor pose for this 1990 photograph. Seated are, from left to right, Attorney Fred Bentley Sr., Mayor J. O. Stephenson, and City Clerk Susan Rackley. Standing are, from left to right, Councilmen Jerry Worthan, Gordon Coker, Pat Ferris, Steve Arrants, and Ben Robertson. (Courtesy of the City of Kennesaw.)

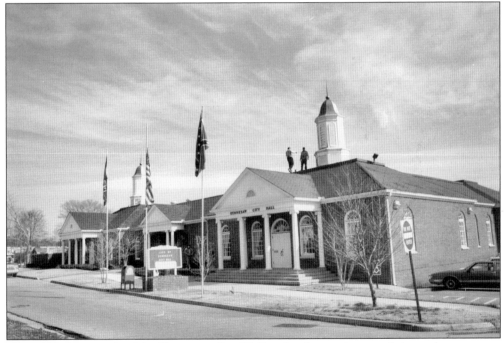

This 1993 photograph of the Kennesaw City Hall and police station stands in stark contrast to the city hall facility of 1969. The city hall complex was built in 1973, and the police station (far left) was added in 1988. (Photograph by Robert Jones.)

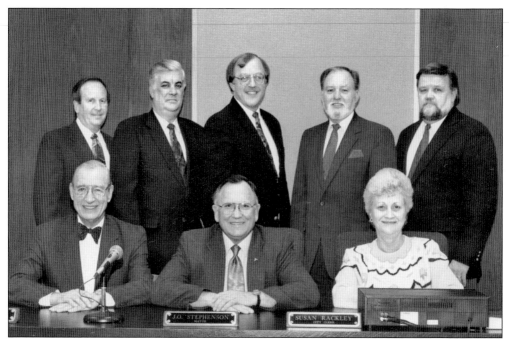

The city council and officials pose in 1994. Seated are, from left to right, city attorney Fred Bentley Sr., Mayor J. O. Stephenson, and City Clerk Susan Rackley. Standing are, from left to right, Councilmen Jack Rowland, Jerry Worthan, Pat Ferris, John Haynie, and Ben Robertson. (Courtesy of the City of Kennesaw.)

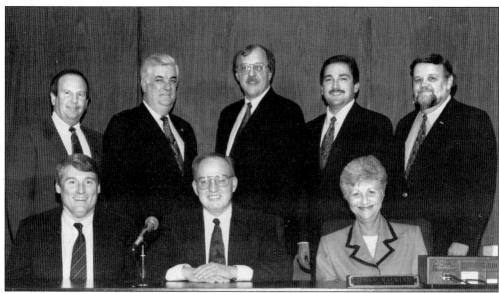

The city council and mayor pose in 1996–1997. Seated are, from left to right, city attorney Fred Bentley Jr., Mayor John Haynie, and City Clerk Susan Rackley. Standing are, from left to right, Councilmen Jack Rowland, Jerry Worthan, Pat Ferris, Mark Matthews, and Ben Robertson. (Courtesy of the City of Kennesaw.)

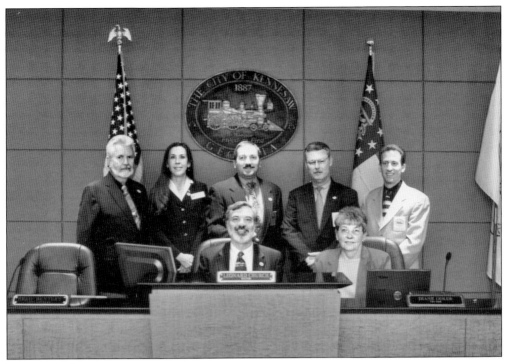

This photograph from April 2004 shows the mayor and council at the first meeting in the new council chambers. Seated are, from left to right, Mayor Leonard Church and City Clerk Diane Coker. Standing are, from left to right, council members John Dowdy, Holly Martin, Mark Matthews, Bill Thrash, and Bob Baker. (Courtesy of the City of Kennesaw.)

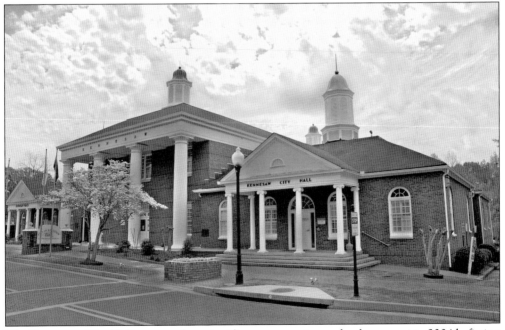

The Kennesaw City Hall went under a significant renovation and enlargement in 2004 befitting a city that now has a population of over 26,000. (Photograph by Robert Jones.)

This water tower can still be seen by the old fire station on Cherokee Street. (Photograph by Robert Jones.)

Five

HOUSES, FARMS, AND ROADS

As noted elsewhere in this work, the first dwellings in Kennesaw were railroad shanties built to house workers on the Western and Atlantic Railroad in the late 1830s and 1840s. By the time of the Civil War, Kennesaw boasted several private dwellings within what would later be known as the city limits. One of the houses was used by William Tecumseh Sherman as a headquarters in June 1864. Today, however, there are no antebellum houses still standing within the 1887 city limits of Kennesaw; they were all burned to the ground by Sherman in November 1864.

Some of the larger houses in Kennesaw today were built during the "boom" years that lasted from around 1890 into the 1920s, when cotton was king, and Kennesaw's prominence as a shipping center brought in increased revenue. The most popular style in the older houses was the pyramid roof, shown in several photographs that follow.

In the 1860 Cobb County Census, 72 percent of heads of households showed "farming" or "farm laborer" as their occupation. Crops included cotton, corn, and various grains. Even as late as the 1980s, Kennesaw was still a very rural area, with several farms within the city limits, and more on the outskirts of town. They are almost all gone now.

Main Street in Kennesaw has had several prominent names over the years. To the Cherokee Indians, it was part of the Peachtree Trail. In the early 20th century, Main Street was part of the Dixie Highway, which ran from Canada to Florida. Main Street in Kennesaw was paved in the 1920s. After Highway 41 opened in the 1950s, bypassing the town center of Kennesaw, Main Street was often referred to as "Old 41." Today it is State Route 293.

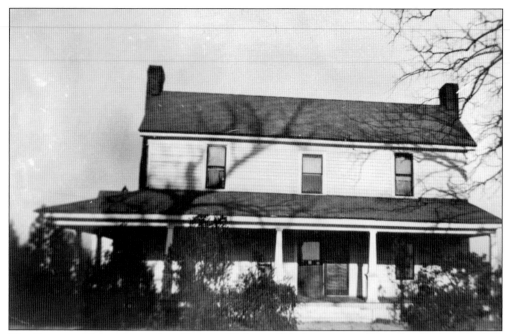

The Summers House, located on Georgia Highway 293 about one mile south of Kennesaw, was a local Kennesaw landmark for many years. Constructed before the Civil War, the house was originally the residence of Thomas F. Summers (1812–1893). The house was purchased by the Ellison family in 1919. (From the collection of Robert Ellison.)

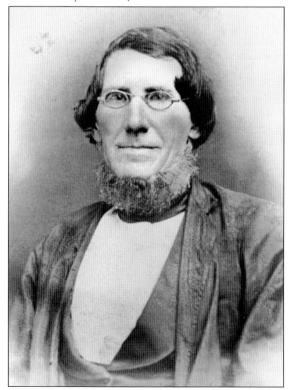

A late-19th-century photograph shows the patriarch of the aforementioned Summers House, Thomas Franklin Summers, who died in 1883. He is buried in the Kennesaw City Cemetery with the words "An honest man, a true citizen, a devoted father, gone to rest" on his tombstone. (From the collection of Ed Chastain; courtesy of the Southern Museum of Civil War and Locomotive History Archives and Library.)

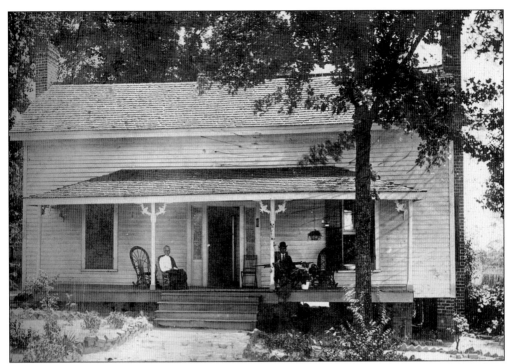

This photograph was taken of Joe .W Carrie and his mother Lady Zenobia Harris Carrie at their home in the early 20th century. (From the collection of Gayle Croft.)

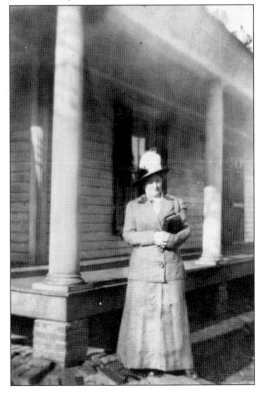

This is an photograph of Lee Gault standing outside a house on Cherokee Street in the second decade of the 20th century. The house was in disrepair by the 1990s (see accompanying photograph) but was restored as part of the Fuller's Chase development. (From the collection of Mrs. Billie Frey.)

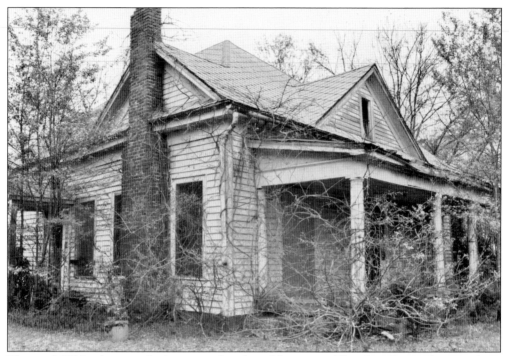

This mid-1990s photograph shows an abandoned house on Cherokee Street that was later restored as part of the Fuller's Chase development. Note the pyramidal, multi-gabled roof lines. (Photograph by Robert Jones.)

The Gault barn was located near the old Gault home on Cherokee Street. The Gault home is now Rose Cottage Furniture, Accents, and Gifts. (From the collection of Mrs. Billie Frey.)

This 1930s photograph shows Paul Howard Skelton and Ralph Skelton on the porch of a house built in 1910. The site now contains a dentist's office. (From the collection of Charlotte T. [Hale] Smith.)

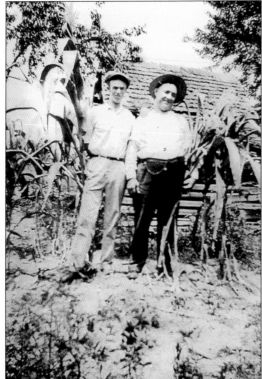

This 1930s-era photograph was taken in the yard of John R. Skelton Sr. (right). Also pictured is Paul H. Skelton. It is easy to forget today that Kennesaw used to be a sleepy rural town, but this photograph bears evidence to the rural nature of old Kennesaw. (From the collection of Charlotte T. [Hale] Smith.)

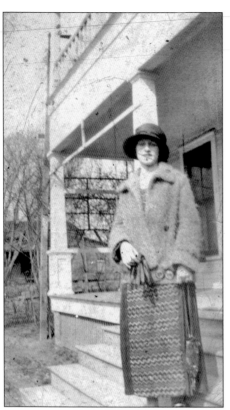

This is a 1930s photograph of the John and Flora Skelton house. The house was still standing in the 1960s but was torn down to build the new Kennesaw Post Office. (From the collection of Mrs. Billie Frey.)

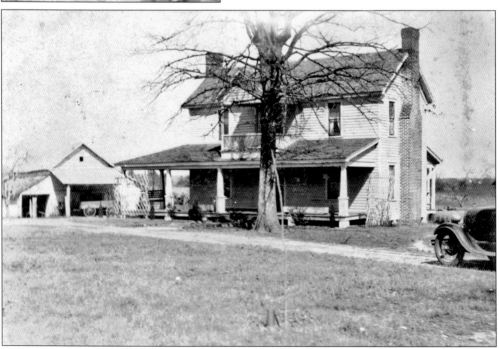

These 1930s photographs show the Summers House after it was purchased by the Ellison family. Note the buckboard in the building on the left. (From the collection of Vivian Chandler Lee.)

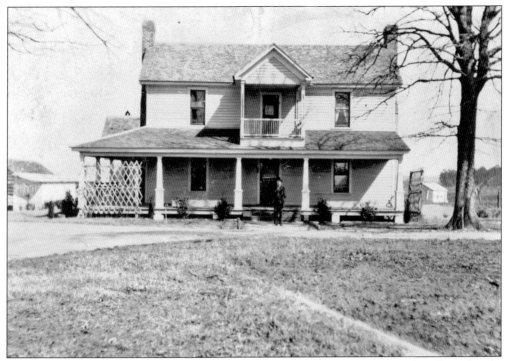

These 1930s photographs show the Summers House after it was purchased by the Ellison family. (From the collection of Vivian Chandler Lee.)

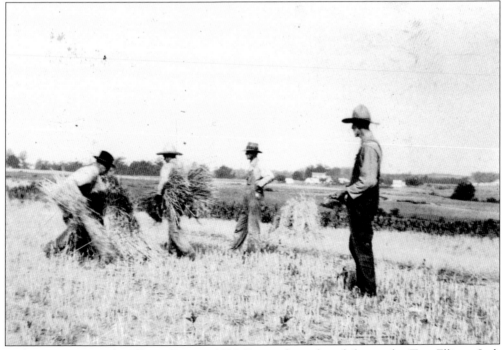

It's harvest time on the Ellison Farm in 1930. Pictured are, from left to right, Tom Ellison, Jack Ellison, Hamp Watson, and Mr. Lewis. (From the collection of Vivian Chandler Lee.)

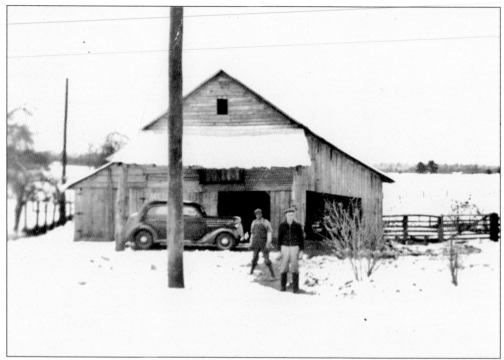

It is definitely wintertime in this snowy 1930s photograph of the Ellison Farm barn. Pictured (closest to the camera) is Howard Ellison. (From the collection of Vivian Chandler Lee.)

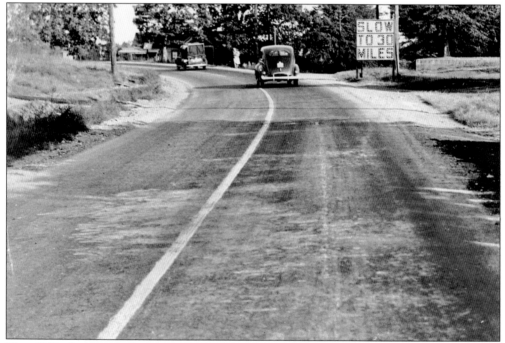

This 1940 photograph shows a section of North Main Street that was once known as "Dead Man's Curve." In 1911, the speed limit in Kennesaw was eight miles per hour. (Courtesy of the City of Kennesaw.)

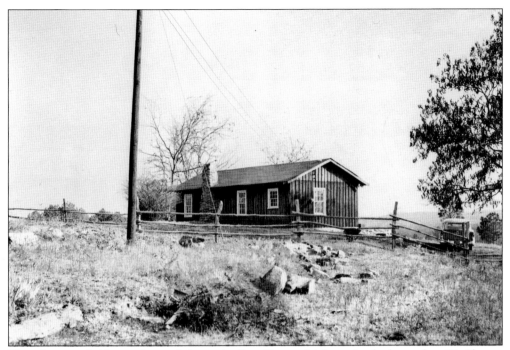

This photograph (date unknown) shows the Burt Farm, which used to be located on Big Shanty Road. (From the collection of the Frank Burt family.)

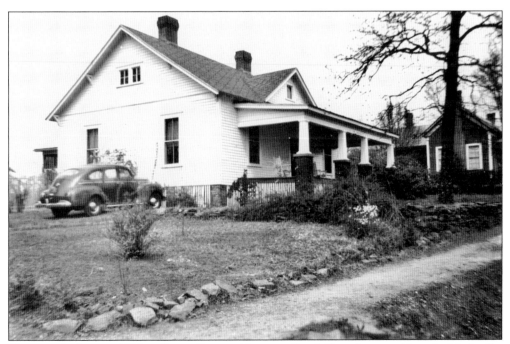

This was the home of Helen Carrie Burt and her son, Frank Burt. It was sold to the Methodist church in 1948. (From the collection of the Frank Burt family.)

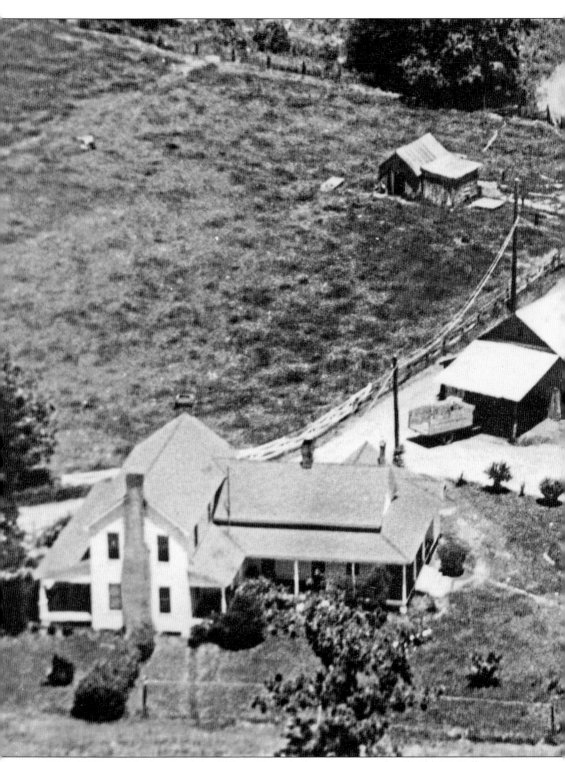

This 1940s aerial view is of the Ellison Farm before it was razed to build McCollum Airport. Pictured are the dwelling house, the pump house, the hay barn, the dairy barn, the calf shed, the

chicken house, the log corncrib, various tool and equipment buildings, and the breeding bullpen. (From the collection of Vivian Chandler Lee.)

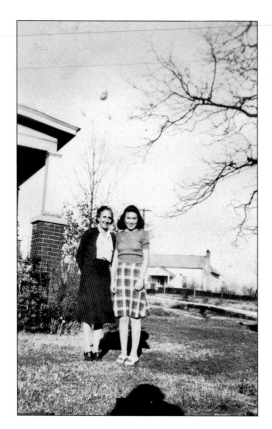

This is a close-up view of the house of Helen Carrie Burt, pictured on the left. The name of the pretty girl on the right is unknown. (From the collection of the Frank Burt family.)

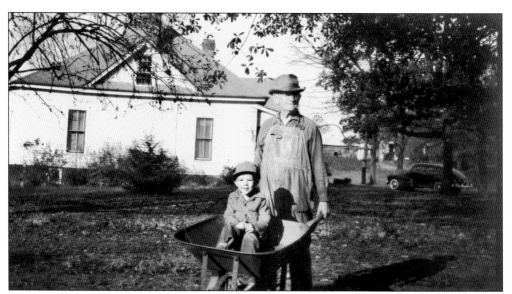

This c. 1949 photograph shows the Fred Robertson house (see photographs of the Robertson garage elsewhere in this book). The man holding the wheelbarrow is railroader George Skelton. The young boy catching the ride is his grandson, Joe Bozeman. (From the collection of Mrs. Billie Frey.)

This photograph was made sometime in the 1940s. This cabin was owned by Bob and Lawton Bozeman and was located on Wooten's Lake in Kennesaw. This cabin was still standing in the 1980s but is now gone and replaced by very expensive homes. (From the collection of Mrs. Billie Frey.)

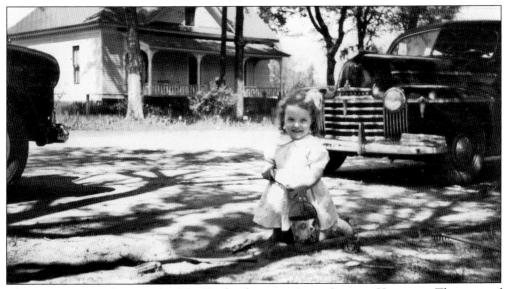

This is a May 1947 photograph of the Hughes house on Lewis Street in Kennesaw. The name of the charming little girl is unknown. (From the collection of Mrs. Billie Frey.)

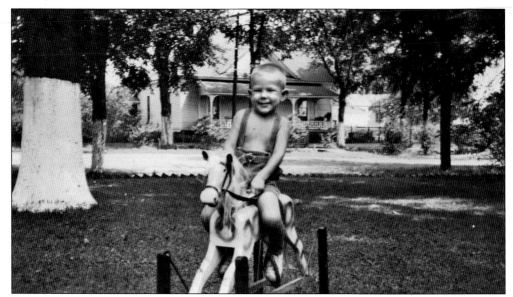

This photograph was made in September 1947. The house in the background was the home of the Hughes family on Lewis Street and was torn down to build the Kennesaw Library. The little boy on the rocking horse is Mrs. Billie Frey's son, Joe Bozeman. He's not as cute today as he was back then. (From the collection of Mrs. Billie Frey.)

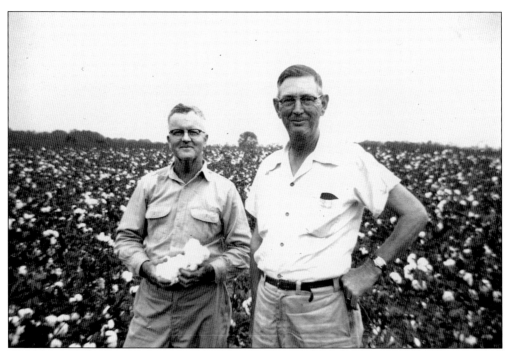

Billy Cantrell (left) and Steve Frey stand in a cotton patch in 1955. Cantrell bought this land from the Jiles family and farmed it for many years. The patch is now the site of the new Swift-Cantrell Park. (From the collection of Mrs. Billie Frey.)

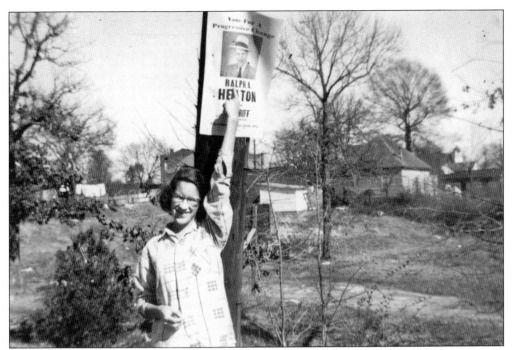

Here we are looking across what is now Watts Drive at the back of the Atkins house in the 1950s. Note the campaign poster. (From the collection of Ann Black.)

This photograph of a house on Route 293 was taken in 1956. The girl on the right is Judy Black. (From the collection of Ann Black.)

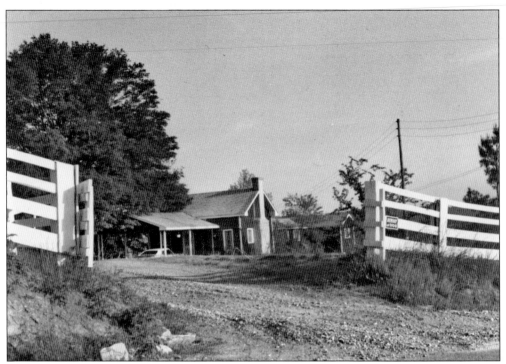

A *c.* 1972 photograph shows the farm off of Moon Station Road where Joe Bozeman Sr. was born. This land is now part of Legacy Park. Until the 1980s, Kennesaw was still primarily a rural community. (From the collection of Joe Bozeman.)

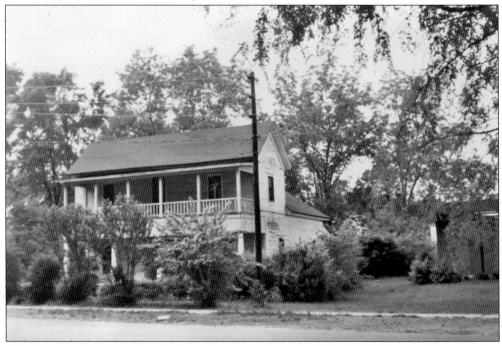

This house was located on Lewis Street. It was torn down in 1969 to build the new Kennesaw Post Office. Dr. Hester's dentist office is on this site today. (From the collection of Joe Bozeman.)

It might be best to only remember some parts of old Kennesaw. This is a picture of George and Cora Skelton's smoke house, located behind their home at 2259 Lewis Street, across the street from the new city hall. This structure was torn down in the late 1970s. (From the collection of Joe Bozeman.)

Main Street in Kennesaw has had several names over the years, including the Peachtree Trail, the Dixie Highway, "Old 41," and Route 293. In the 1990s, there was still a sliver of the pavement of the Dixie Highway visible. It has since been paved over. (Photograph by Robert Jones.)

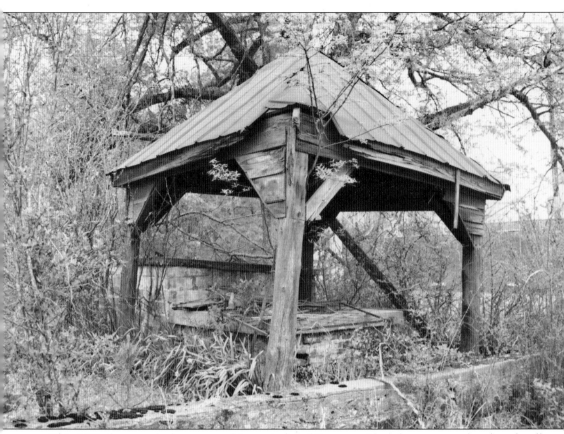

This 1996 photograph shows a graphic reminder of Kennesaw's rural roots—an abandoned well house located on Cherokee Street, just several blocks from the downtown area. It has since been restored as part of the Fuller's Chase development. (Photograph by Robert Jones.)

Six

MUSEUM

The modern Southern Museum of Civil War and Locomotive History sits today on land that at one time was a cotton field. Around 1928, a cotton mill was built on the site of the present-day museum. This structure burned down in 1945 and was replaced by the existing building in which the *General* stands today.

In 1972, the Frey family donated the cotton mill to the City of Kennesaw to provide a permanent home for the *General*. On February 19, 1972, the back side of the mill was removed so that the *General* could be eased off the back of a truck into the new Big Shanty Museum. April 12, 1972, was opening day at the Big Shanty Museum, 110 years after the Andrews Raid.

In the mid-1990s, the Big Shanty Museum was renamed the Kennesaw Civil War Museum, a name which stuck with the building until the new museum opened in 2003.

In the late 1990s, the Kennesaw Museum Foundation was formed to find a home for the Glover Machine Works collection, said by the Smithsonian Institute to be the finest collection of its kind. (The locomotive works operated from the late 19th century to 1930 in nearby Marietta.) Eventually the decision was made to enlarge the existing Kennesaw Civil War Museum to include the Glover exhibits.

The $6-million Southern Museum of Civil War and Locomotive History opened for business on March 30, 2003. The new, 40,000-square-foot museum houses displays on three major areas of focus—the Civil War (especially Civil War railroading), the Glover Machine Works collection, and the Great Locomotive Chase. The new museum was built around the old museum, so the *General* still occupies the same spot it has since 1972.

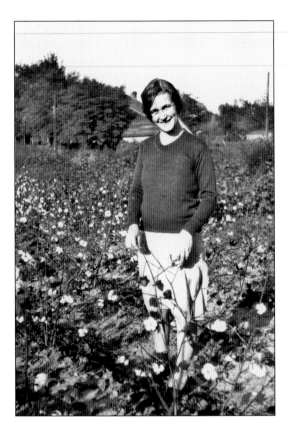

This 1928 photograph shows Dorothy Elizabeth Thomas standing in the cotton field where the modern-day museum is located. (From the collection of Charlotte [Hale] Smith.)

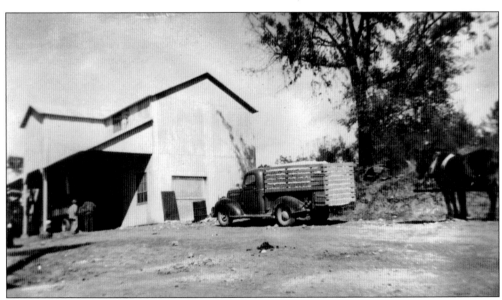

This rare photograph (c. 1940) shows the original c. 1928 cotton mill built on the site of the present-day museum. This structure burned down in 1945 and was replaced by the existing building, where the *General* stands today. Note the two forms of transportation. (Courtesy of the Southern Museum of Civil War and Locomotive History Archives and Library.)

The Frey cotton gin is seen as it appeared on the eve of the return of the *General* to Kennesaw (1972). The land and building were donated to the City of Kennesaw by the Frey family to house the *General*. (Courtesy of the Southern Museum of Civil War and Locomotive History Archives and Library.)

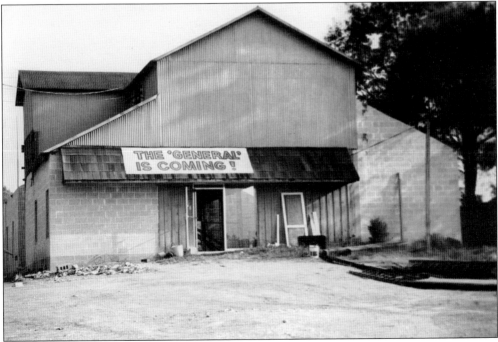

In this 1972 photograph, the Frey cotton gin is awaiting the return of the *General*. Note the sign that states, "The 'General' is coming!" (Courtesy of the Southern Museum of Civil War and Locomotive History Archives and Library.)

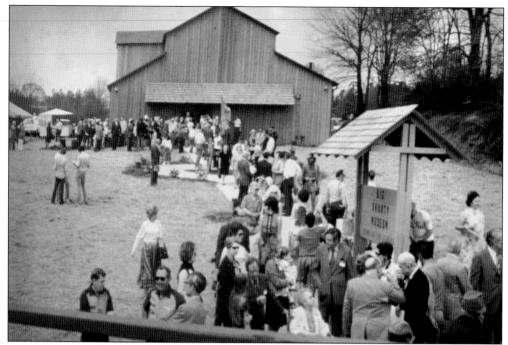

April 12, 1972, was opening day at the Big Shanty Museum, 110 years after the Andrews Raid. Note that the museum lacks a marquee at this point. (Courtesy of the Southern Museum of Civil War and Locomotive History Archives and Library.)

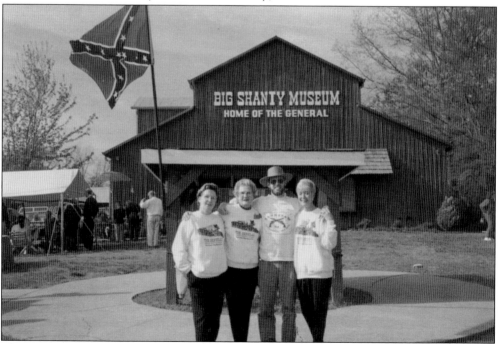

This 1993 photograph of the Big Shanty Museum depicts (from left to right) Genie Lee, museum director Cathy Fletcher, Kennesaw Historical Society president Robert Jones, and Carolyn TeBeest. The three ladies were all museum employees. (Photograph by Robert Jones.)

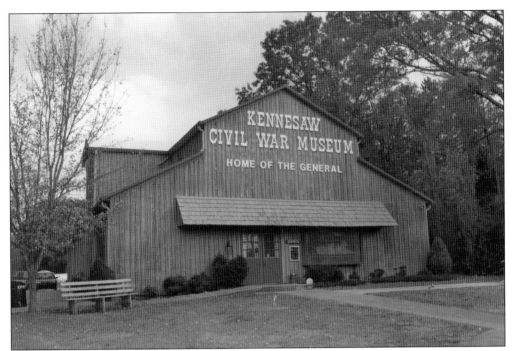

In the mid-1990s, the Big Shanty Museum's name was changed to the Kennesaw Civil War Museum. This name would stick until the new museum was opened in 2003. (Photograph by Robert Jones.)

Museum manager Harper Harris is ready to lead a school tour in the Kennesaw Civil War Museum in 2000. (Photograph by Robert Jones.)

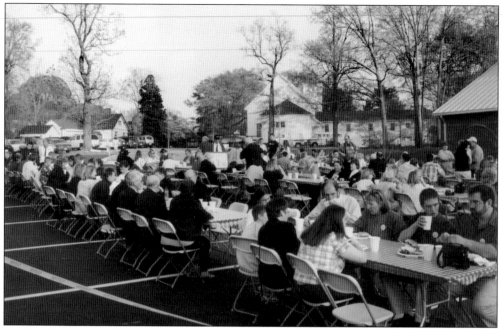

In March 2003, on the eve of the opening of the new Southern Museum of Civil War and Locomotive History, the museum sponsored a cookout for descendants of participants in the Andrews Raid. (Photograph by Robert Jones.)

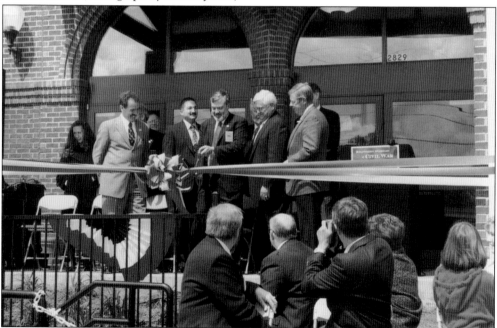

The Southern Museum of Civil War and Locomotive History opened on March 30, 2003. The new, 40,000-square-foot museum houses displays on the Civil War, the Glover Machine Works, and the Great Locomotive Chase. Pictured in the ribbon-cutting ceremony are (from left to right) Holly Martin, U.S. Congressman Phil Gingrey, Mark Matthews, Mayor Leonard Church, Paul Chastain, and U.S. Sen. Johnny Isakson. (Photograph by Robert Jones.)

Seven

PEOPLE

In the early 19th century, Northwestern Georgia was home to over 20,000 Cherokee Indians. By 1838, almost all of the Cherokees had been driven out of Georgia, victims of (among other factors) the Dahlonega Gold Rush. The first inhabitants of Kennesaw were Cherokees who were undoubtedly attracted to the area for the same reason that the later railroad was—the more than 12 springs in the area. The 1830s survey maps for the Cherokee land lottery still exist and show that there were some Cherokee structures located approximately at the intersection of Route 41 and Highway 293 in modern-day Kennesaw.

The first white inhabitants of Kennesaw were railroad workers working on the Western and Atlantic Railroad in the late 1830s. By the time of the Civil War, the area known as Big Shanty had a population of over 700 people, with 65 percent the inhabitants working in agriculture and 12 percent working for the railroad.

By the end of the Civil War, there were few people left living in Kennesaw, as almost all structures had been burned to the ground by Sherman in November 1864. Even by 1880 (seven years before incorporation), Kennesaw only had 200 residents.

As the table below shows, the population of Kennesaw didn't go over 1,000 until 1960. By 2006, the population of Kennesaw is over 26,000.

This chapter shows a cross-section of people, mostly in the 1900–1940s year range, including soldiers, homemakers, nurses, farmers, railroad men, shopkeepers, children, Boy Scouts, cloggers, and a beauty queen.

KENNESAW POPULATION FIGURES
(Population figures courtesy Kennesaw Historical Society.)

Year	Population
1860	718
1880	200
1900	320
1908	500
1940	426
1950	564
1960	1,507
1970	3,548
1980	5,095
1990	8,936
2000	21,675

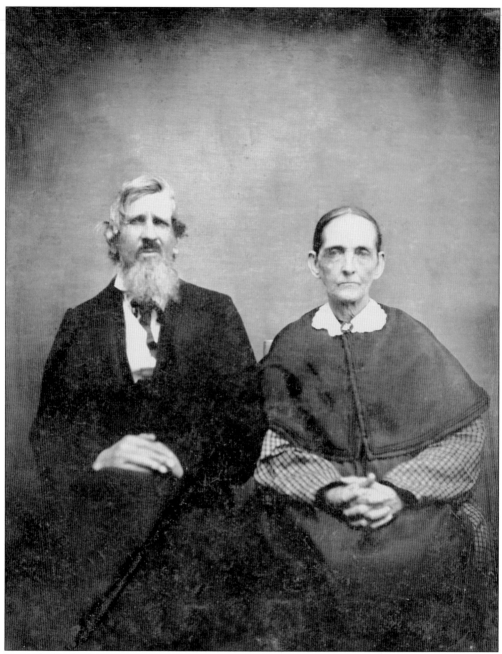

Lemuel Kendrick and his wife are shown in this 1860s tintype photograph. In the late 1850s, Kendrick provided the land upon which the Lacy Hotel was built by the Western and Atlantic Railroad. According to the 1860 Cobb County Census, Lemuel Kendrick had the richest real-estate holdings in Big Shanty. (From the Ed Kendrick Collection; courtesy of the Southern Museum of Civil War and Locomotive History Archives and Library.)

Earl Dallas Lewis Thomas, age 21, married Essie Clara Roberts, age 16, on September 12, 1894. (From the collection of Jana Davis.)

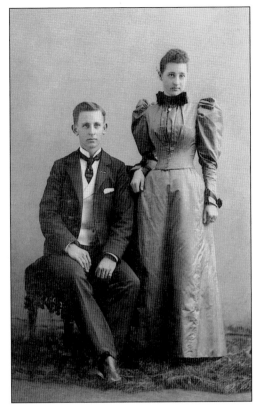

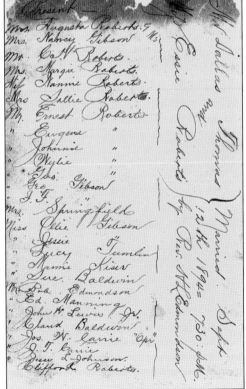

This is the list of guests that were invited to the Roberts-Thomas wedding. According to this card, they were married by Reverend Edmondson at 7:30 p.m. (From the collection of Jana Davis.)

This early-20th-century photograph shows Hallie Guthrie, grandmother of Ed Hollingsworth, who would become police chief of Kennesaw in the 1960s. (From the collection of Ed Hollingsworth.)

An early-20th-century photograph shows Benjamin Harris Carrie (who died in 1936). (From the collection of the Frank Burt family.)

Mrs. Benjamin Harris Carrie (born Tallulah Brintle) poses in a picture that was probably taken at the same time as her husband, pictured on the previous page. (From the collection of the Frank Burt family.)

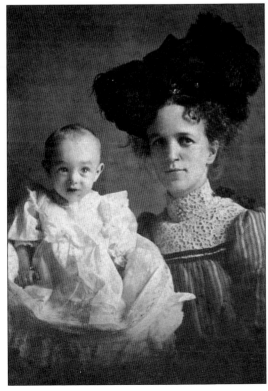

This *c.* 1902 photograph shows Flora Tollison Skelton, wife of John R. Skelton Sr., with a young John R. Skelton Jr. (From the collection of Charlotte Thomas [Hale] Smith.)

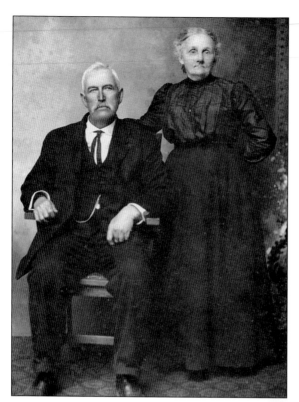

Victoria Chalker Skelton stands next to Jim Skelton—the last survivor who witnessed the theft of the *General*. (From the collection of Joe Bozeman.)

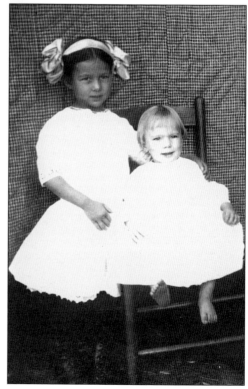

Mary Lou Bozeman poses with Joe Bozeman Sr. in 1913. Joe Bozeman Sr. would grow up to be the father of one of the authors of this book. (From the collection of Mrs. Billie Frey.)

Marine Joseph Baldwin Thomas served in France, where this photograph was taken during World War I. (From the collection of Jana Davis.)

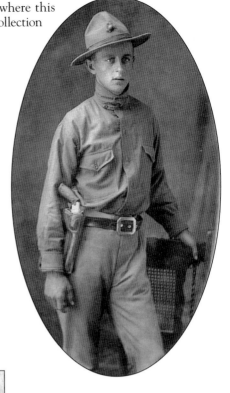

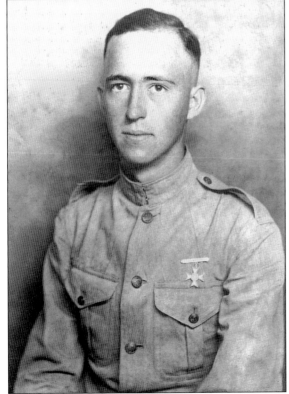

This is a photograph taken in France during World War I of U.S. Marine John Harmon Thomas. This brave soldier was killed by a sniper while stringing communication wire. (From the collection of Jana Davis.)

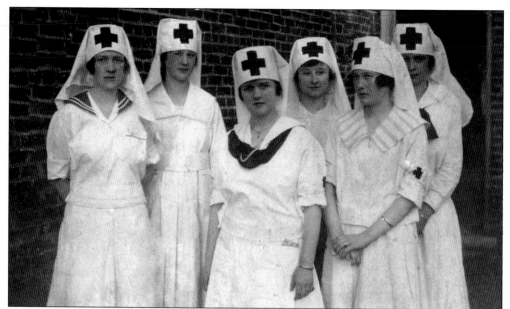

Women from Kennesaw also served in World War I, as this photograph of Kennesaw nurses shows. (From the collection of Mrs. Billie Frey.)

A *c.* 1918 photograph in Kennesaw shows Charlie H. Rogers, Mary Thomas, Nannie Roberts, Louise Thomas, and Margie Gibson Roberts. (From the collection of Jana Davis.)

John Skelton Sr. shows off a rifle around 1920. Posing with him are Bill Hildenbrand and Mary Lou ?. (From the collection of Joe Bozeman.)

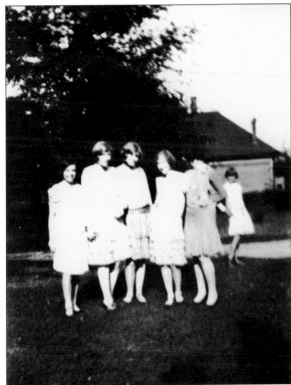

Carolyn Skelton did not want her little sister in the picture. But her little sister (now Mrs. Billie Frey) jumped into the background at the last second and made a cute pose. Pictured from left to right are Florence Jones, Louise Scroggs, Sue Adams, Carolyn Skelton, and Mildred Lewis. The photograph was made on Lewis Street. (From the collection of Mrs. Billie Frey.)

This c. 1920 photograph shows Louise Thomas, Nannie Roberts, and Inez Thomas. (From the collection of Jana Davis.)

Carolyn Skelton (left), Louise Scroggs (center), and Mildred Smith (right) are all dressed up and celebrating Fourth of July in grand 1920s style. (From the collection of Mrs. Billie Frey.)

Fourth of July could not be celebrated without Uncle Sam, and this little guy was the perfect child for the part. Uncle Sam is Joe Bozeman Sr. (From the collection of Mrs. Billie Frey.)

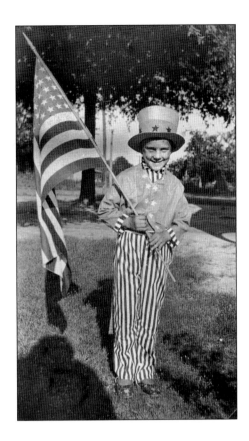

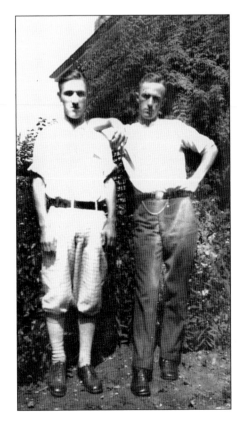

This 1920s photograph shows Paul Howard Skelton (left) and John Richard Skelton Jr. in front of the Skelton house on Lewis Street. (From the collection of Charlotte T. [Hale] Smith.)

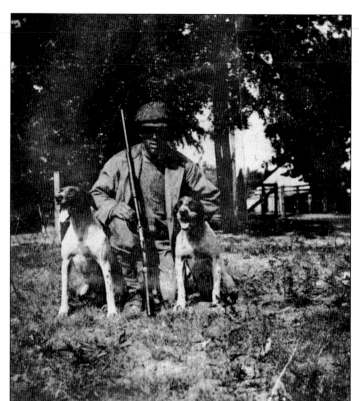

Hoss Bozeman prepares to go hunting with his bird dogs at a farm on Moon Station Road in the 1920s. (From the collection of Joe Bozeman.)

This photograph shows a 1920s farm on Moon Station Road. (From the collection of Joe Bozeman.)

Four families—the Roberts, Thomases, Gibsons, and Ellises—gather for a family reunion on the Roberts farm c. 1925. (From the collection of Jana Davis.)

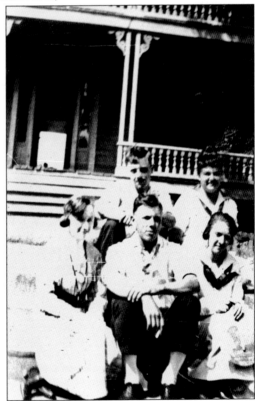

From left to right, (top row) Harvey McKlesky and Sara Hill; (bottom row) Flora Lester, Hoss Bozeman, and Lee Gault pose in front of the Hill house on Lewis Street in the 1920s. (From the collection of Mrs. Billie Frey.)

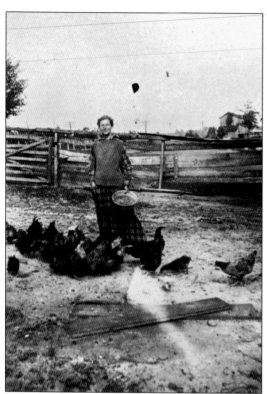

Della Bozeman feeds some chickens near the Bozeman barn off of North Main Street in the 1920s. (From the collection of Mrs. Billie Frey.)

This photograph of John Richard Skelton Jr. and Dorothy Elizabeth Skelton Thomas was taken in Kennesaw c. 1925. (From the collection of Charlotte Thomas [Hale] Smith.)

Riding a pig in the late 1920s was a lot of fun for little Ben Carrie, as long as his mother, Mrs. Joe Carrie, hung on to him. (From the collection of Gayle Croft.)

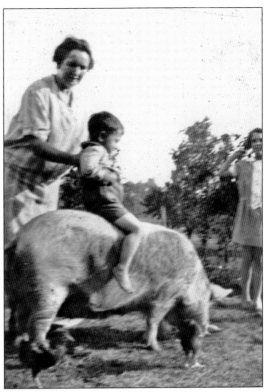

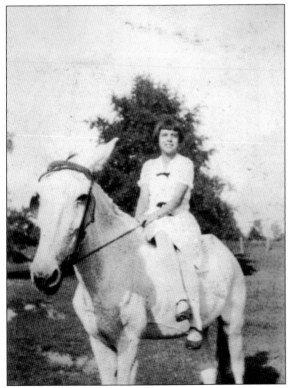

Florence Brooks Jones rides a horse on North Main Street on August 28, 1927. (From the collection of Mrs. Billie Frey.)

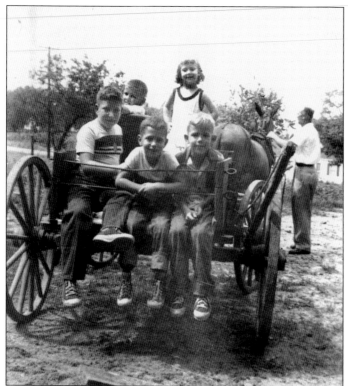

Joe Bozeman Sr. (pictured at far right) used to give children rides in his mule-drawn wagon. This photograph was taken near the Bozeman barn on North Main Street. The mule's name is Sally. (From the collection of Mrs. Billie Frey.)

This 1928 photograph shows John R. Skelton Sr. (top) with Edwin Thomas, his grandson. The house in front of which this photograph was taken has since been torn down. Dr. Hester's office is now on the site. (From the collection of Charlotte T. [Hale] Smith.)

This photograph shows Margie Gibson Roberts (left) and Nannie Roberts in the late 1930s. (From the collection of Jana Davis.)

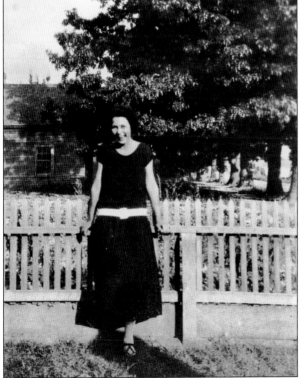

This photograph of Mary Lou Bozeman was made in the 1930s. The house in the background was the home of the Morris Brooks family on North Main Street. This house is still standing and was recently remodeled by Chad Carroll. (From the collection of Mrs. Billie Frey.)

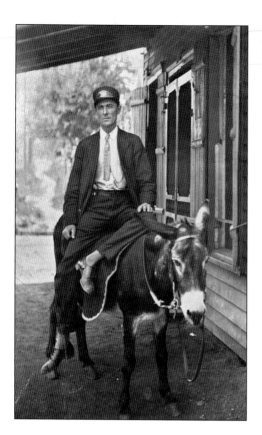

Jim Bozeman, in an Atlanta police uniform, rides a donkey on North Main Street. (From the collection of Mrs. Billie Frey.)

This photograph of Mr. and Mrs. Joe Bozeman was taken on March 31, 1941. The barn in the background still stands today. (From the collection of Mrs. Billie Frey.)

John Richard Skelton Sr. relaxes in an automobile. (From the collection of Charlotte Thomas [Hale] Smith.)

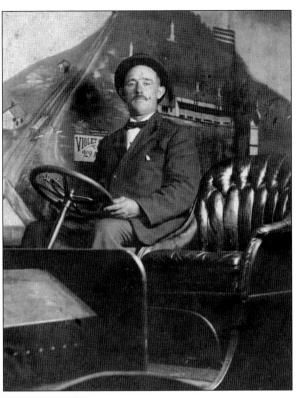

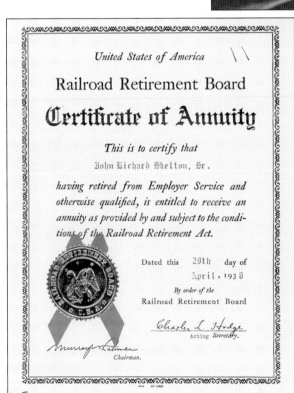

When John Richard Skelton Sr. retired from the NC&StL in 1938, he received this retirement certificate. The NC&StL rolled through Kennesaw from 1891 to 1957, when it was acquired by the L&N. (From the collection of Charlotte Thomas [Hale] Smith.)

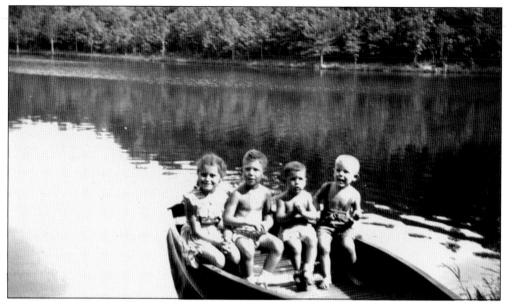

The children pictured above are soaking up the sun while happily awaiting their boat ride on Wooten's Lake on September 3, 1947. (From the collection of Mrs. Billie Frey.)

Frank Burt and mother Helen Carrie Burt pose in front of their house near the Kennesaw Methodist Church. (From the collection of the Frank Burt family.)

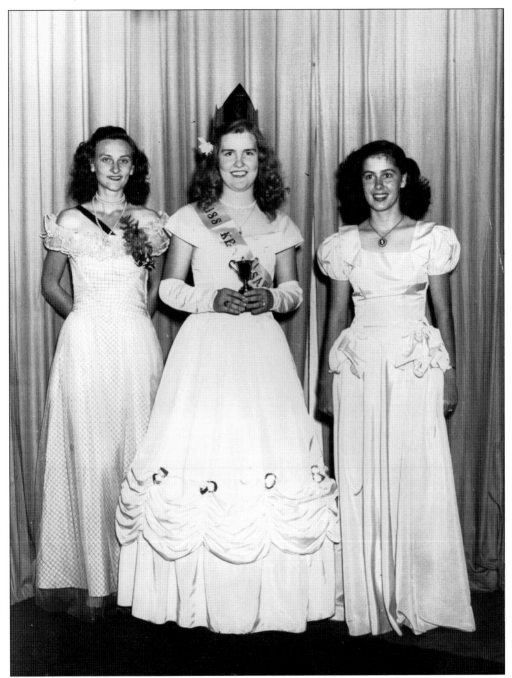

Here she is, Miss Kennesaw 1949, Vivian Chandler. Vivian is surrounded by Blondene Leonard on her left and Miss Lewis on her right. This was the first beauty pageant ever held in Kennesaw. (From the collection of Vivian Chandler Lee.)

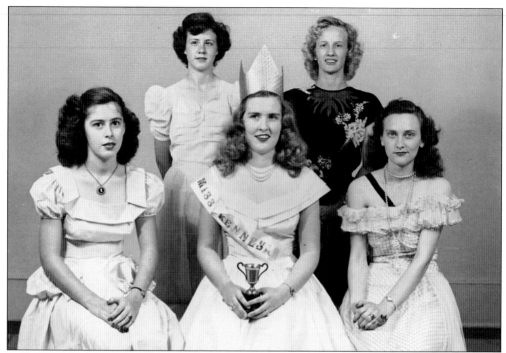

In this photograph of the Miss Kennesaw Pageant in 1949, sitting from left to right are Miss Lewis, Vivian Chandler, and Blondene Leonard. Pictured standing from left to right are Carol Owenby and Olivia Smathers, pageant coordinator. (From the collection of Vivian Chandler Lee.)

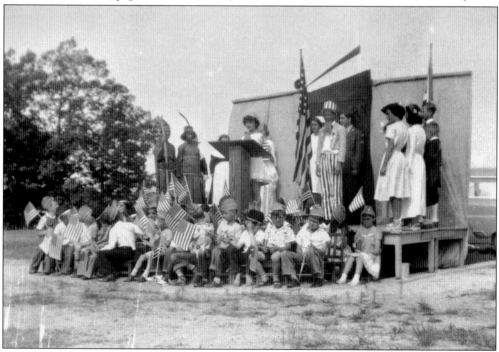

Children and grown-ups alike celebrate May Day in 1950. (From the collection of Joe Bozeman and Mrs. Billie Frey.)

This is a picture of Wayne Taylor and his mother, Matti, made around 1957. They moved to Kennesaw in the late 1940s. He was born with one arm, but that never held him back. Wayne spent his retirement days walking in the downtown area with his orange vest on, smiling and waving to all that passed his way. He died in 2006, and he is missed dearly. (From the collection of Dent Myers.)

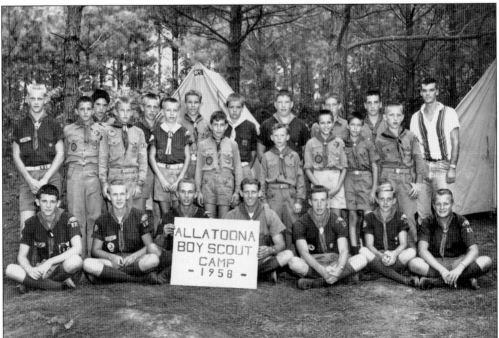

The Kennesaw Boy Scouts visited Camp Allatoona in 1958. Future city councilman Ben Robertson can be seen in the back row center, with the tent visible over his right shoulder. (From the collection of Joe Bozeman.)

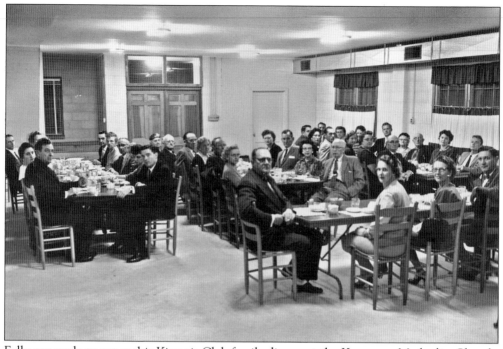

Folks are ready to eat at this Kiwanis Club family dinner at the Kennesaw Methodist Church. (From the collection of Eleanor Skelton Bozeman.)

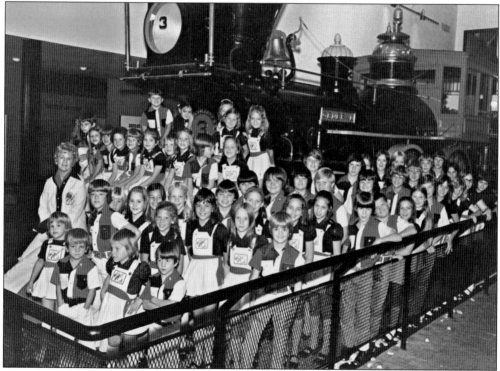

The world-famous Little General Cloggers pose in front of their namesake c. 1970. (From the collection of Eleanor Skelton Bozeman.)

George R. Skelton advertises a turkey shoot for the Kennesaw Kiwanis Club in the 1950s. (From the collection of Mrs. Billie Frey.)

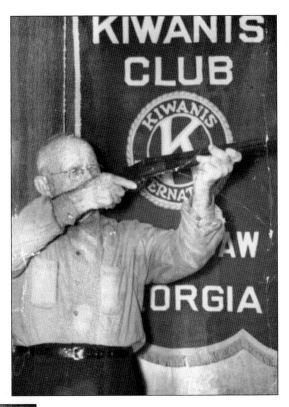

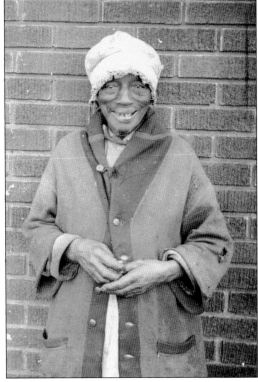

"Aunt Mary Miller," as this woman was known (date unknown), lived on "Rocky Street," now known as Moon Station Road. (From the collection of Mrs. Billie Frey.)

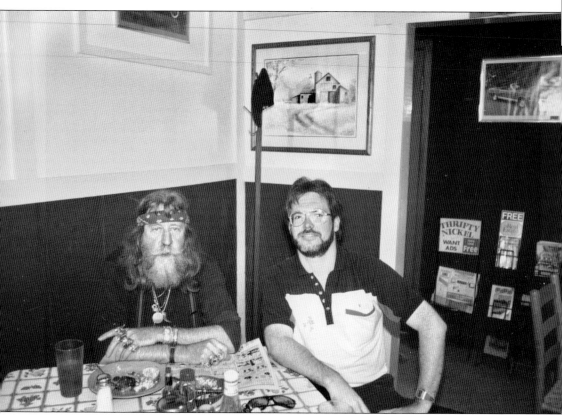

Dent Myers (left), pictured here in 1993, opened Wildman's Civil War Surplus and Herb Shop in 1976 in the old Kennesaw State Bank building. Wildman's is still a prominent landmark in downtown Kennesaw in the 21st century. (Photograph by Robert Jones.)

Eight

SCHOOL

The Kennesaw Consolidated School was built in 1908 next to the city cemetery. Tragedy struck in the late 1930s, when the school burned to the ground. A new school, simply called the Kennesaw School, was built soon after. In 1938, the school had 384 students and 11 teachers (grades one through eight). During World War II, the school expanded to include high school students.

Mrs. Billie Frey offers her reminiscence about attending the old school:

In 1924 I started my 12 years of education in the old red brick building near the Kennesaw cemetery. The school was a two-story building with four rooms downstairs—a wide hall through the middle from the front door to the back door with two rooms on each side. The first room on the left was the first grade room. As you were promoted you advanced to another room ending up in the first room on the right.

Each room had a big, cast iron stove that burned either wood or coal. It was up to the older boys to keep the fire going. At times they would have those stoves actually red hot. If you sat too close, you were hot, and if you sat too far, you were cold.

The upstairs was the auditorium with a stage and a hall behind the stage that connected a dressing room on each side. My mother directed many plays held there to make money for the school.

At this time, we had not had electricity long, and we sure did not have running water and sewage. We had out houses. The girl's was down toward the cemetery and the boy's on the other side down a hill out of sight.

There was a well in the front of the building with a cover that resembled a gazebo. The water was drawn up by a windless with a rope attached to a bucket. There was a dipper and if you had your own cup, you used the dipper to fill your cup. If you did not have a cup, you drank from the dipper. Luckily no child ever fell in the well. I guess germs were not as plentiful then as now because I never heard you could catch something from someone else. I do remember having diphtheria—so maybe I got it from the dipper.

We had no organized sports. The girls played volleyball and basketball in the front of the building. The boys played baseball in the back.

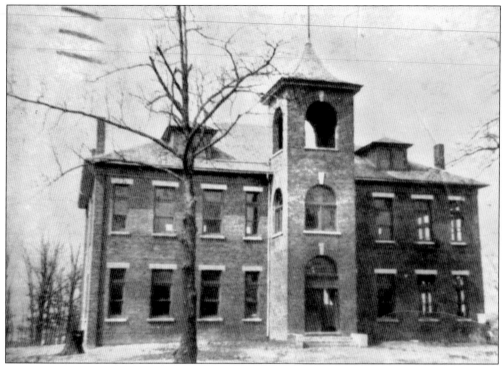

The original Kennesaw Consolidated School (built 1908) burned to the ground in the late 1930s. (Courtesy of the Southern Museum of Civil War and Locomotive History Archives and Library.)

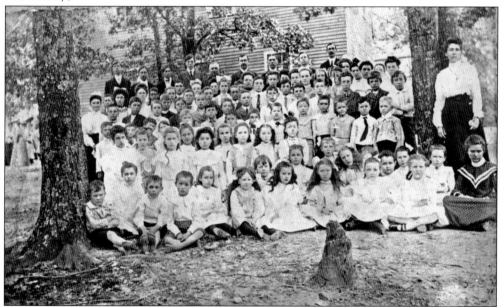

This photograph is marked 1903–1904, and seems to be taken in front of a wooden school that predates the Kennesaw Consolidated School. The teacher is identified as Mollie Reece (or Reese). Helen Carrie Burt is pictured on the second row, fourth from the left. (From the collection of the Frank Burt family.)

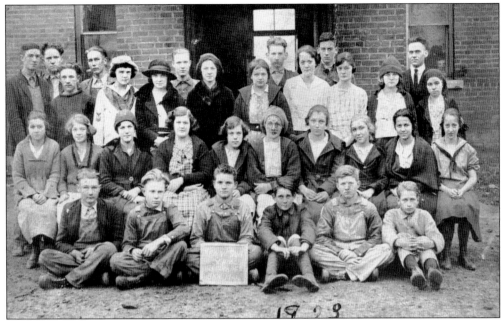

This 1923 photograph of the Kennesaw School shows the upper grades. Sixth from left on the second row is Ruby Chandler, pictured elsewhere is this book as the proprietor of a grocery store. (From the collection of Vivian Chandler Lee.)

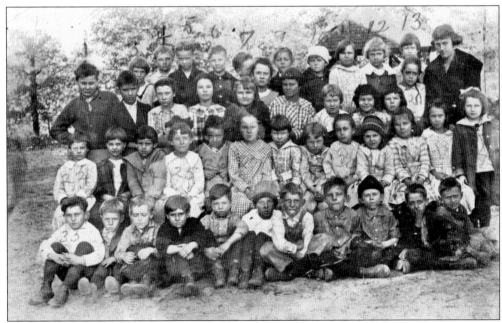

Among the family names represented in this photograph of the Kennesaw School are Ellison, Wigley, Dyer, Clayton, Cook, Hilderbrand, Skelton, Duncan, Lewis, Robertson, Tyson, Hall, Garrett, Pritchard, Kirk, Miller, Bonds, and Scroggs. (From the collection of Joe Bozeman.)

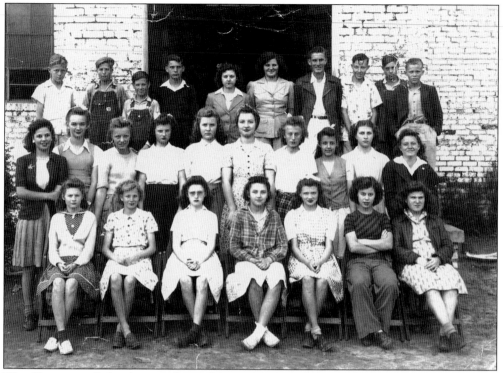

The Kennesaw School seventh grade poses in 1945. (From the collection of Vivian Chandler Lee.)

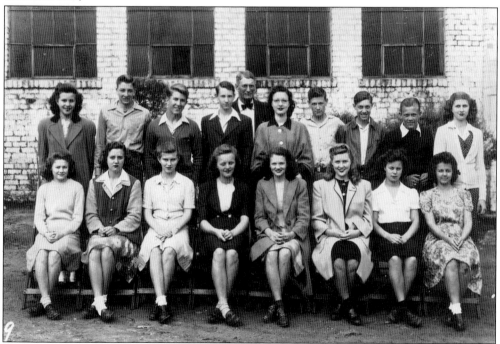

Pictured here is the Kennesaw School ninth-grade class of 1946. (From the collection of Vivian Chandler Lee.)

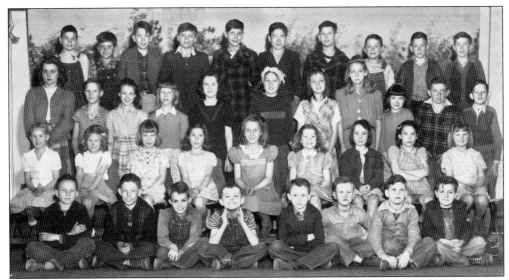

This 1947 photograph shows the third grade at Kennesaw Elementary School. (From the collection of Robert Ellison.)

This photograph shows the Kennesaw Elementary School lunchroom in 1956. Note the boys with ties and dress shirts and the girls with long dresses. (From the collection of Ann Black.)

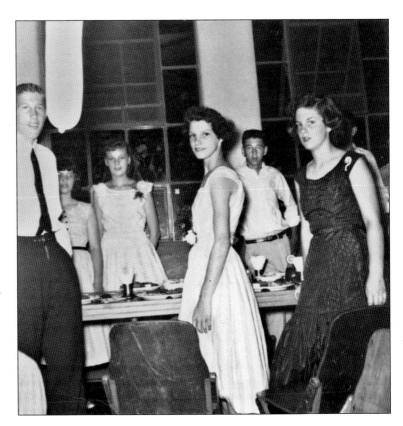

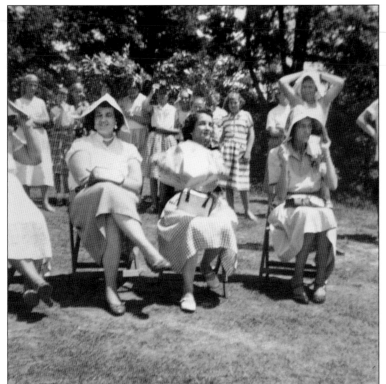

It is Field Day at the Kennesaw Elementary School playground in the 1950s. Pictured left to right are Lois Ferris, Mrs. Royales, and Miss Williams shielding themselves from the hot Georgia sun. (From the collection of Ann Black.)

Teacher Shelbia Warren is pictured with her first-grade class on the lawn in back of the Kennesaw Elementary School in 1955. (From the collection of Ann Black.)

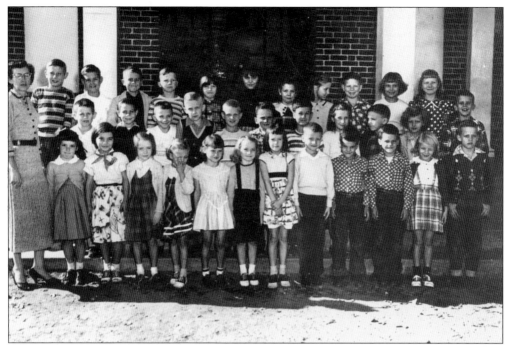

This 1956 photograph of the Kennesaw Elementary School shows the class of Millie M. Dennis. (From the collection of Mrs. Billie Frey.)

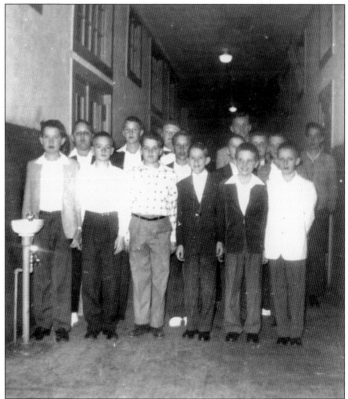

This 1957 photograph from Kennesaw Elementary School shows former city councilman Ben Robertson front and center. (From the collection of Joe Bozeman.)

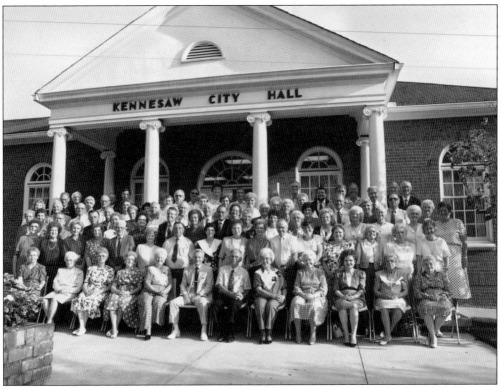

A late-20th-century Kennesaw School reunion poses on the steps of city hall. (From the collection of Eleanor Skelton Bozeman.)

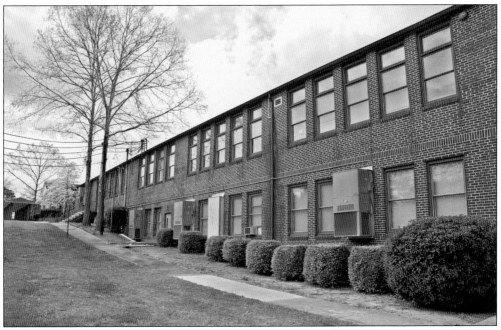

The old Kennesaw School, built in the late 1930s, is now the Martha J. Moore Transitional Center, owned by Cobb County. (Photograph by Robert Jones.)

Nine

SPORTS

Kennesaw has always had a vibrant set of youth-oriented sports programs, with baseball probably being the most popular. Today, with the fabulous Adams Park complex, organized youth sports are very popular. However organized sports have not always been the norm. Joe Bozeman reminisces on what youth sports were like in the 1950s and 1960s.

> In the 1950s there were no organized sports in Kennesaw. The kids played baseball in "The Park," a sandlot ballpark located where the Kennesaw City Hall is today. Football was played in Fred Robertson's back yard on Lewis Street. During the summer there was always a baseball game going on, and in the fall, football was played all Sunday afternoon.
>
> In 1954, Bill Weeks and Joe Bozeman Sr. organized a baseball team for the young boys. This team played every Saturday morning at what is now Adams Park. At that time, competition was limited to playing two teams, one from the Acworth Methodist Church and the other from the Acworth Baptist Church. An official Little League team did not exist in Kennesaw until the 1960s.
>
> Football was played in Robertson's backyard until 1957. Norman Lanier and J. O. Stephenson organized a "Midget Football" team that was the predecessor of the Kennesaw Generals.
>
> When one looks at the number of sports teams in Kennesaw today, it is hard to believe that it was actually difficult to fill the positions with kids in the 1950s.

Most of the photographs in this chapter date from the 1930s–1960s, when youth sports were in their infancy in Kennesaw. Also represented are several photographs from the Kennesaw Smokers, a semi-pro baseball team named after a popular cigar brand, and photographs from the old Cobb County Recreation Center.

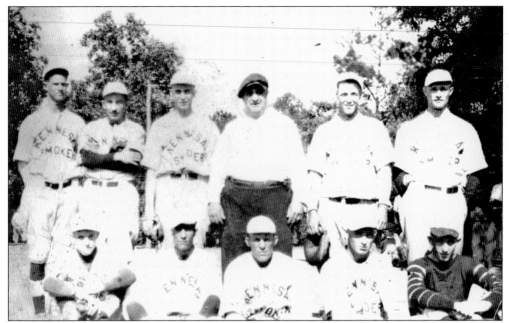

This *c.* 1922 photograph shows the Kennesaw Smokers, named after a popular cigar brand. The manager was Joe Gluck. Those pictured include Horace Adams, Mel Pendley, Morris Brooks, Hoy and Lloyd Cantrell, Joe Gluck (sometimes spelled Glueck), and Frank McCutcheon. (From the collection of Mrs. Billie Frey.)

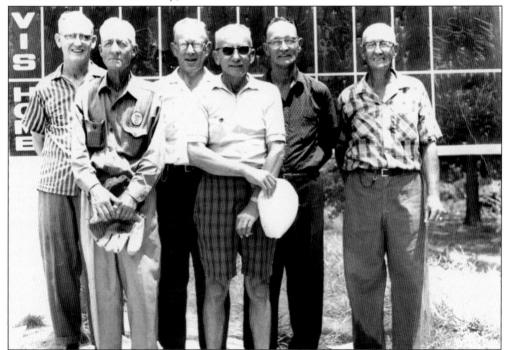

This *c.* 1960 reunion of the 1920s Kennesaw Smokers includes Melvin Pendley (second from left), Hoss Bozeman, Bob Bozeman (in shorts), Clarence Gallagher, and Frank McCutcheon. (From the collection of Mrs. Billie Frey.)

The Evans boys pose at their house on Lewis Street in the 1920s, ready for archery, football, and cowboys and Indians. (From the collection of Mrs. Billie Frey.)

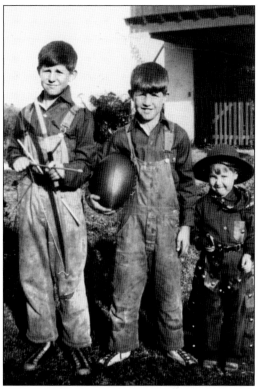

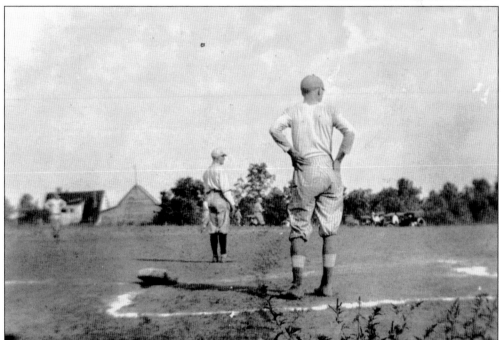

This 1930s photograph is of a baseball game being played in what is today Adams Park. Today Adams Park covers 33 acres and has 11 baseball/soccer fields. (From the collection of Mrs. Billie Frey.)

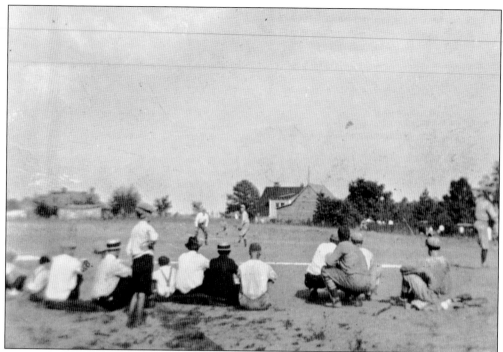

This 1930s photograph shows a baseball game being played in what is today Adams Park. The house in the background may have been the home of the Lewis family. (From the collection of Mrs. Billie Frey.)

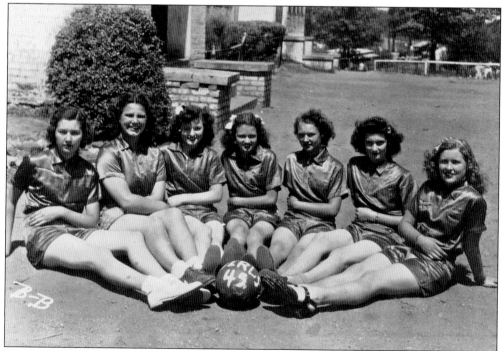

The 1945 Kennesaw Junior High School women's basketball team poses for a photograph. (From the collection of Vivian Chandler Lee.)

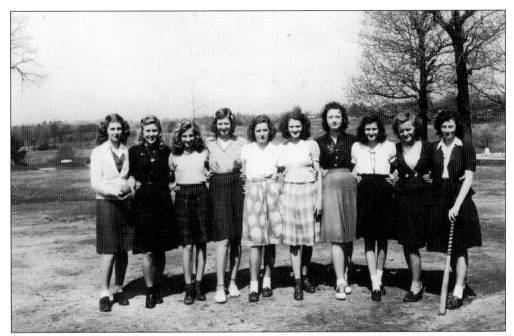

The 1946 Kennesaw Junior High School girls' softball team poses with ball and bat. (From the collection of Vivian Chandler Lee.)

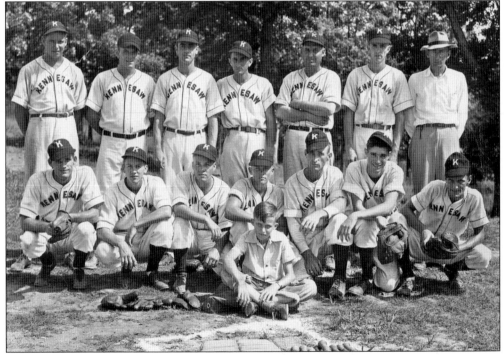

The Kennesaw Smokers pose for a group photograph in the early 1950s. Those pictured include Guy Willbarks, Billie Chastain, Troy Chastain, Bill Weeks, J. C. Cantrell, Wayne Leonard, Glenn Skelton, Junior Jiles, Johnny Adams, Grady Robertson, Mr. Bailey, and Golden Adams. (Photograph by Alexander Pictures; from the collection of Mrs. Billie Frey.)

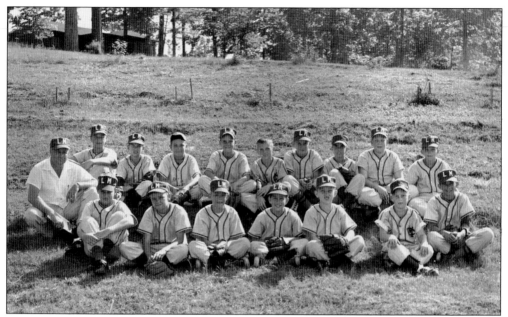

A Kennesaw baseball team poses on the first "field of dreams" in 1956. In the 1950s, "Preacher" Clackum built his own baseball field, called Clackum Field. Any boy who wanted could play. (From the collection of Joe Bozeman.)

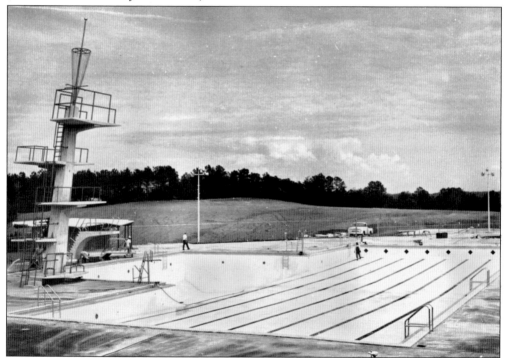

This c. 1960 photograph shows the swimming pool at the Cobb County Recreation Center. A promotional brochure published at the time says, "This swimming facility is the only one in the South—and one of only five in the nation—meeting all requirements for Olympic and Pan-American Games." (From the collection of Eleanor Skelton Bozeman.)

This is a 1960s photograph of the Cobb County Recreation Center (now Pinetree Country Club) swimming pool in Kennesaw. Pictured are, from left to right, Lerrie Jenkins, Dick Boyer (father of Atlanta Braves pitcher Blaine Boyer), and Chris Haynes. (From the collection of Joe Bozeman.)

In 1960, a lifeguard shows off at the Cobb County Recreation Center (now the Pinetree Country Club) swimming pool in Kennesaw . (From the collection of Joe Bozeman.)

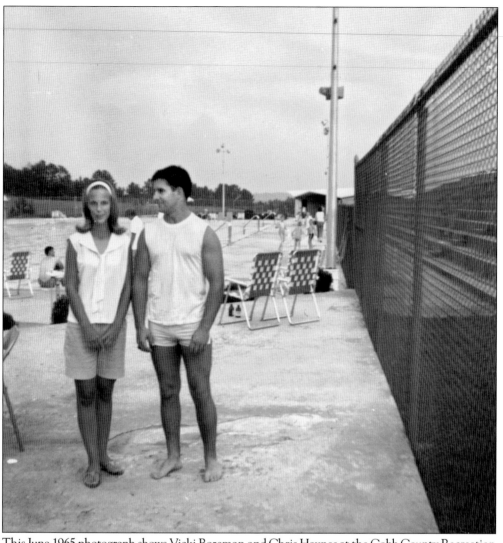

This June 1965 photograph shows Vicki Bozeman and Chris Haynes at the Cobb County Recreation Center swimming pool in Kennesaw. (From the collection of Joe Bozeman.)

BIBLIOGRAPHY

First Baptist Church: 100 Years Preaching Christ: 1877–1977. Kennesaw: Kennesaw First Baptist Church, 1977.

The History of Kennesaw United Methodist Church (http://www.kennesawumc.org/index-old.html).

Jones, Robert. *Kennesaw (Big Shanty) in the 19th Century*. Kennesaw: Kennesaw Historical Society, 2000.

———. *Kennesaw in the 20th Century*. Kennesaw: Kennesaw Historical Society, 2004.

———. *The Law Heard 'Round the World: An Examination of the Kennesaw Gun Law and its Effect on the Community*. Kennesaw: Kennesaw Historical Society, 1994.

Smith, Mark H. *History of Kennesaw*. Kennesaw: *Kennesaw Gazette*, 1980–1981.

———. *History of Kennesaw: 1900–1930*. Unpublished.

Trains magazine. July 1962.